A NEW DEAL *for the* ARTS

By

Bruce I. Bustard

National Archives and Records Administration
Washington, DC

In association with

The University of Washington Press
Seattle and London

Published by the National Archives Trust Fund Board
And the University of Washington Press

Printed in Hong Kong

Library of Congress Cataloging-in-Publication Data

Bustard, Bruce I.
 A New Deal for the arts / by Bruce I. Bustard.
 p. cm.
 Catalog based on an exhibition at the National Archives, Washington, DC, Mar. 28, 1997– Jan. 11, 1998.
 Includes bibliographical references and index.
 ISBN 0-295-97600-4 (alk. paper)
 1. Federal Art Projects—Catalogs. 2. Federal aid to the arts—United States—Catalogs. 3. New Deal, 1933–1939. I. United States. National Archives and Records Administration. II. Title.
NX735.B87 1997
700'.973'09043—dc20 96-31607
 CIP

The paper used in this publication meets the minimum requirements of the American National Standards for Permanence of Paper for Printed Library Materials Z39.48-1992.

Designed by Serene Feldman Werblood, National Archives and Records Administration

Cover:

Untitled Winter Scene

By Ceil Rosenberg, Public Works of Art Project, 1934, oil on canvas

Franklin D. Roosevelt Library, National Archives and Records Administration (MO 69-62)

Back cover:

Poster for Portland, Oregon, production of One-Third of a Nation

By an unknown artist, 1938, silkscreen

National Archives, Records of the Work Projects Administration (69-TP-160)

Contents

P R E F A C E

This catalog and the exhibit upon which it is based tell the story of several short-lived, but remarkable, cultural endeavors—the New Deal arts projects. During the depths of the Great Depression of the 1930s and into the early years of World War II, the federal government, as one of its efforts to employ some of the millions of Americans then without work, supported the arts in unprecedented ways. For 11 years, between 1933 and 1943, federal tax dollars employed artists, musicians, actors, writers, photographers, and dancers. Never before or since has our government so extensively sponsored the arts.

Both the exhibit and this book draw extensively on the holdings of the National Archives and Records Administration (NARA), especially those of the Franklin D. Roosevelt Library and Museum. Among these holdings are the records of FDR's "alphabet soup" agencies such as the Agricultural Adjustment Agency (AAA), the Works Progress Administration (WPA), the Civilian Conservation Corps (CCC), the National Youth Administration (NYA), and the National Recovery Administration (NRA). These records include not only letters, memorandums, and policy directives but also photographs, motion pictures, drawings, maps, posters, and sound recordings. Records of the New Deal arts programs include Federal Theatre Project posters, costume and set designs, studies for post office murals, prints and negatives from photography projects, books and pamphlets produced by the Federal Writers' Project, and voluminous administrative records describing how the arts projects evolved.

The Roosevelt Library and Museum is located in FDR's home town of Hyde Park, New York. It is the nation's first Presidential library, established in 1939, when FDR donated his papers to the federal government. The library includes not only the official papers of his Presidency but also the papers of First Lady Eleanor Roosevelt and those of their associates. Its large audiovisual collection encompasses photographs and motion pictures of the President and his family, government movies, newsreels, and sound recordings. The museum houses thousands of artifacts ranging from FDR's stamp and ship model collection to Roosevelt's specially designed automobile. There is also a collection of prints, paintings, and sculptures from the Federal Art Project.

The Roosevelt Library is one of 33 NARA facilities located nationwide whose mission is to provide ready access to essential evidence that documents the rights of American citizens, the actions of federal officials, and the national experience. I invite you to inspect for yourself the record of your government by visiting our research facilities, participating in our educational programs, or viewing our exhibits. In our democracy, the records that constitute the National Archives belong to all citizens.

John W. Carlin
Archivist of the United States

List of Acronyms

AAA	Agricultural Adjustment Administration
CCC	Civilian Conservation Corps
CWA	Civil Works Administration
FSA	Farm Security Administration
FAP	Federal Art Project
FMP	Federal Music Project
FSA	Farm Security Administration
FTP	Federal Theatre Project
FWP	Federal Writers' Project
IAD	Index of American Design
NLRB	National Labor Relations Board
NRPB	National Resources Planning Board
NRA	National Recovery Administration
NYA	National Youth Administration
PWAP	Public Works of Art Project
RA	Resettlement Administration
REA	Rural Electrification Administration
TVA	Tennessee Valley Authority
WPA	Works Progress Administration (until July 1, 1939)
	Work Projects Administration (after July 1, 1939)

ACKNOWLEDGMENTS

This publication is based on the 1997 National Archives and Records Administration (NARA) exhibition, "A New Deal for the Arts." Both the exhibition and publication were prepared by NARA's Office of Public Programs under the direction of Charles W. Bender, Sandra Glasser, Edith M. James, and Christina Rudy Smith. Michael L. Jackson designed the exhibition; James D. Zeender was the project registrar; Mary C. Ryan edited the manuscripts; Serene Feldman Werblood designed the catalog; Thomas Nastick developed the exhibition video; Sarah Bertalan was the chief exhibit conservator.

Outside of NARA, Virginia Mecklenburg, National Museum of American Art; John Rumm, the Smithsonian Institution's Traveling Exhibition Service; Dwight Bowers, National Museum of American History; James Morris, The Production Group; and Samuel Larcombe, an independent scholar, gave of their expertise and time to review the exhibit and catalog manuscripts. Both works were immeasurably improved because of their critiques. Mark Palumbo, Kimberly Cody, and Courtney DeAngelis, National Museum of American Art; Karen Werth and Robert Blitz, University of Maryland Art Gallery; Alicia Weber, General Services Administration Fine Arts Collection; Charles Ritchie, Martha Blakesly, and Melissa Stegman, National Gallery of Art; and Iambra Johnson, Judith Grey, and Walter Zvonchenko, Library of Congress, all graciously gave me assistance with their collections. Independent conservators Polly Willman, Catherine Valentour, and Lesley Lankler conserved several objects in the show. Independent registrar Stephanie Jacoby completed condition reports on many exhibit items. Robert H. McNeill gave permission to reproduce one of his photographs. Donald Ellegood of the University of Washington Press was an enthusiastic supporter of the catalog at every stage. As always, Tory Bustard was a constant source of care and encouragement.

At NARA, Darlene McClurkin, Lisa B. Auel, Stacey Bredhoff, Stephen Estrada, Marilyn H. Paul, Mary Lynn Ritzenthaler, Norvell Jones, Barbara Pilgrim, William Blakefield, Benjamin Guterman, Bill Creech, Wayne Cole, Diane Dimkoff, Rod Ross, Emily W. Soapes, Nicholas J. Natanson, Stephen Glenn, Beth Havercamp, Earl McDonald, Walter Hill, Mary Illario, Janet Davis, Edward McCarter, Cynthia Hightower, Wynell Schamel, Robert C. Morris, Nancy Mottershaw, Giuliana Bullard, Susan Cooper, and Judy Edelhoff offered their assistance unstintingly. The staff of the Franklin D. Roosevelt Library and Museum, especially Alycia Vivona, Wendall Parks, and Gerald Kolenda, were unfailingly helpful during the week I spent in Hyde Park, New York, doing research, and they continued to help throughout the project.

Exhibitions and catalogs are enormously collaborative undertakings. I am grateful to everyone who has been a part of this project.

Bruce I. Bustard
Exhibits Branch, National Archives

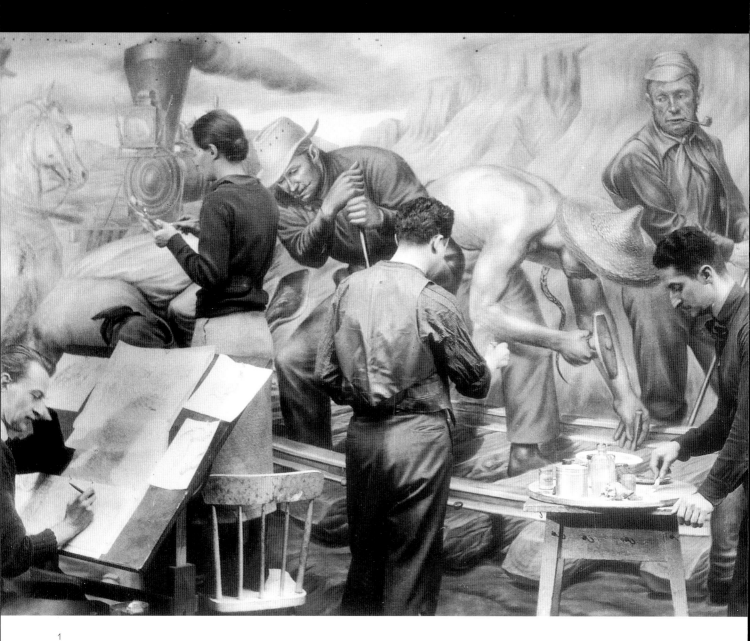

1
"Edward Laning and assistants at work on his mural,
THE ROLE OF THE IMMIGRANT IN THE INDUSTRIAL DEVELOPMENT OF
AMERICA. Done under the WPA Federal Art Project for
the Dining Room of Ellis Island."
By an unknown photographer, undated
National Archives, Records of the Work Projects Administration
(69-AG-413)

A **New Deal** *for the* **Arts**

Artists and the Great Depression

In April 1934, as America struggled into its fifth Great Depression spring, 11½-year-old Ruth Zakheim sent a letter to Washington, DC, about her father, artist Bernard Zakheim. During the winter, Bernard had painted a fresco in San Francisco's Coit Tower for the federal government's Civil Works Administration's (CWA) Public Works of Art Project (PWAP). Now, however, the mural was finished, the PWAP ended, and Zakheim was again without a job. "I was wondering if there was another fresco he might do," wrote Ruth to Edward Bruce, the head of the PWAP (fig. 2). "He needs the money so badly. . . . Mother says we may lose our home if we do not make the next installment on the mortgage." Despite Ruth's plea to "never let my parents know I wrote this letter," Bruce wrote back but could offer neither her nor her father encouragement. Of course, "this does not mean the Government is not interested in the artists and the work they have done." Over the next few months he hoped "a nation-wide plan" would be devised to employ people like her father.

Bernard Zakheim's situation was hardly unique. The Great Depression was the greatest economic catastrophe in United States history. By the end of 1932, soup lines and homelessness were commonplace, and almost 13 million Americans were out of work (fig. 3). Artists were no exception to this misery. Struggling even in the best of times, during the Depression many artists found themselves jobless and without the resources to pursue their vocations. Writers saw book sales fall by one-half; musicians faced a 70-percent unemployment rate; painters traded canvases for rent; out-of-work actors lined up for relief. Desperate, a group of New York

City artists started an outdoor art market. An observer described the scene as they bartered their creations:

> A canvas for a wedding ring. A watercolor for a new shirt. An etching for a carton of cigarettes and the price of a bottle of wine! Artists who wouldn't dream of joining any charity lists are broke. Broke or nearly so, they have come to offer their dreams in paint for vegetables, clothes, or luxuries they cannot afford.

Other artists wrote to Washington, outlining their predicaments and asking the government for help. "I find it very difficult under the present circumstances to paint and at the same time to support my wife and child," wrote Moses Soyer. His brother Isaac, also a painter, added that his family had been ill and that he had been forced to borrow to pay the hospital bills. He could paint only "under the worst possible conditions" since he had no money for a studio or models and was "constantly worried about the payment of bills." Alexander Dux admitted that he was "only one of the many thousands of artists caught in this maelstrom of want and despair" but insisted that he and his family could not survive on the $12 he earned doing census work 3 days a week. More poignantly, George Franklin wrote: "I am almost ready to give up. I have only one hope left—the CWA—and it'll probably fizzle out the way that all the others did. In that case, it is eight bells for me. I'll go below and get more sleep. I'm tired."

In the early 1930s, millions of Americans found themselves in similar straits. The spectacular stock market crash of October 1929 was followed by a less dramatic but more

San Francisco, Calif.,

April 7, 1934

Jamestown

Dear Mr. Bruce;

I am only 11½, but I fell I must
write this letter to you.

My father used to work for the
C. W. A. art projects in San Fran-
cisco. He did a fresco in the Coit
tower. Now he is finished and
I was wondering if there was a-
nother fresco he might do. He needs
the money so badly. I have heard
him say you were the originator
of the C. W. A. for artists. His
name is Bernard B. Zakheim

Please do see if you have another
job for him I am sending a pic-
ture of him with the fresco he
did at the Jewish Community center
Mother says we will lose

2

**Letter from Ruth Zakheim to Edward Bruce,
April 7, 1934**

National Archives, Records of the Public Buildings Service

our home if we do not pay the
next installment on the mor-
gage. Please write to Dr. Hyler
who is in charge of the C. W. A.
artists in San Francisco but
never let my parents know a-
bout this letter.

yours truly,

Ruth Zakheim

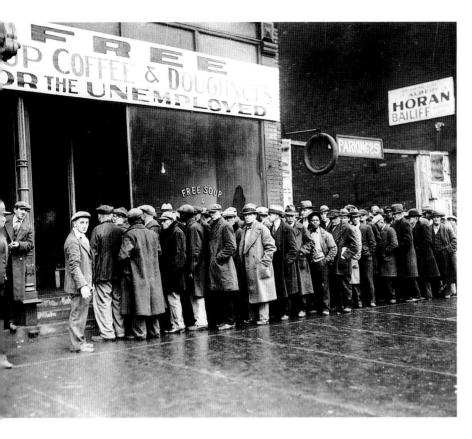

3

Unemployed queued up at a Chicago soup kitchen

By an unknown photographer, February 1931
National Archives, Records of the United States
Information Agency (306-NT-165-319c)

disastrously widespread collapse of the American economy. To make matters worse, in 1930 and 1931 a devastating drought struck parts of the South and Midwest. As the Depression continued to deepen, the human toll from these calamities was enormous. Workers who lost their jobs soon depleted their savings and had to turn to private charity or the local poor fund for assistance. Those who lost their homes or were evicted from their apartments sometimes ended up living in urban shantytowns or joining the thousands of new migrants beginning to wander the countryside. Farmers who managed to avoid foreclosure and drought could not market their crops and allowed them to rot in the fields, while in the cities malnutrition was on the rise.

As industry and agriculture declined and unemployment rose to astounding levels, policymakers struggled with little success to right the American economy. President Herbert Hoover, who had come into office in 1929 with a reputation for humanitarianism and progressive efficiency, soon shouldered much of the blame in the public's mind.

While he took action that went beyond what the federal government had ever done to promote an economic recovery, he resisted suggestions that government do more. In 1931 he vetoed several attempts to provide further federal help for the unemployed or those stricken by drought. He also opposed the early redemption of World War I pensions for veterans. In 1932, when a large group of unemployed veterans camped in Washington, DC, in support of an early pension "bonus," Gen. Douglas MacArthur used federal troops under his command to drive the hapless "bonus army" from the nation's capital. Privately, Hoover was unhappy with the general's actions, but in public he defended MacArthur and thereby brought down a storm of criticism upon himself.

Such actions cost Hoover dearly in public support, and by mid-1932, a Presidential election year, change was in the air. The election quickly became a referendum on the President's policies of limited government action to fight the Depression and dispensing relief locally to ease the plight of the unemployed. In response, the Democratic candidate, New York Governor Franklin Delano Roosevelt, criticized Hoover for his unwillingness to do more but offered few specifics of his own beyond pledging "a new deal for the American people." By election day, anger at Hoover's refusal to take bolder action and fears about the worsening economy gave Roosevelt and the Democrats an overwhelming victory.

ARTFUL POLICIES

By Franklin Roosevelt's inauguration in March 1933, the American economy had hit bottom. Industrial investment was down to almost nothing, bank closings created "runs" as customers lined up to withdraw any savings they had left, and the army of the unemployed grew larger than ever. "We were all like people on a raft," recalled one struggling writer, "sharing a world of common disaster." In response, Roosevelt promised the nation "bold, persistent experimentation," and over the next few months the nation got it. The President proposed and Congress created a host of new agencies while enacting a flood of legislation that used the federal government to promote recovery and regulate the economy. During his first 100 days, FDR signed legislation to regulate banking and the stock market, control agricultural production, stabilize wages and prices, and allow homeowners to refinance their mortgages.

The most urgent need was putting Americans back to work, and here, too, Roosevelt moved decisively. To replenish the local relief funds and charities that had been bled dry, he asked Congress to authorize a half-billion dollars for relief to be funneled through the states. He also authorized a huge public works program and created agencies such as the Civilian Conservation Corps to employ jobless young men in reforestation and other conservation work. But as spring turned to summer, it became apparent that there would be no quick solution to the unemployment crisis and that even more massive federal assistance would be needed to get the country through the approaching winter. It was then that FDR created the Civil Works Administration and asked his relief administrator, Harry Hopkins, to run it. At its peak, in mid-January 1934, the CWA employed more than 4 million people on federally funded public works projects. Workers were paid an hourly wage for work that ranged from teaching school to digging at archaeological sites to building bridges, roads, and airports. Over the winter of 1933–34, the CWA pumped a billion dollars into the U.S. economy.

But what about the nation's artists? Several proposals under discussion went beyond traditional work relief schemes. The most influential came from George Biddle, an artist and lawyer who had attended Groton and Harvard with President Roosevelt. In May 1933 Biddle wrote a "Dear Franklin" letter to his old classmate suggesting that the United States follow Mexico's lead and employ artists "at plumber's wages" to paint murals on the walls of government buildings. American artists, he was sure, were anxious to memorialize in murals "the social ideals you are struggling to achieve." Roosevelt suggested Biddle discuss his idea with Treasury Department official Lawrence Robert. Robert was intrigued, and he and Biddle soon found an ally in Edward Bruce, another Treasury official who was also a painter. Together, Bruce, Biddle, and Robert held a series of dinner meetings with interested New Dealers. In November, Bruce and Biddle produced a plan to employ painters, printmakers, sculptors, and muralists to embellish public buildings. The next month, Harry Hopkins announced that $1,034,754 of CWA money would go to the Public Works of Art Project (PWAP). Bruce was named its Director.

Over the next 5 months the PWAP employed more than 3,700 artists at hourly

Aug. 28, 1934

Edward B. Rowan
Assistant Technical Director, etc. etc.
Washington, D.C.

Dear Sir:

Taking you seriously, if it is the object of your plan to give a certain number of writers, presumably creative, a certain amount of money for mere subsistance, I can think of nothing better for it than to draw up a recommended list of names, pay them and tell them to go ahead with whatever they have in mind - and that if anything of value is produced that it will be published. In any case they get paid.

But if excellence in itself, literary excellence, should by chance be the prime objective, as it should be, the difficulty is insuperable. Or nearly so. Some will be too radical in thought for countenance by the government, others will be thought obscene, etc. There's nothing you can do about that.

I'd like to see a National Dep't of Letters or, lest it become a literary mausoleum, a department of creative letters, or living letters. I wonder, in the spirit of Geo. Washington, whether the country is sufficiently broad minded for that. A monthly periodical, paying its contributors, could be maintained, well printed, free from the necessity of putting boodle in someone's pockets; it should print whatever is well written, regardless of its political complexion, the emphasis being on the writing only. But this, I am afraid, is too french for us. After a year or two the best that had been published in the magazine should be put into book form. It would be a safety valve for us all, but it would have to be edited by a superb spirit, altogether unfamiliar in these temperatures. The gesture would be superlative though only a small number of writers would be helped.

What might prove better would be an issue of paper books, the books to be selected by individual publishing houses, a limited number by each according to its equipment and importance, the Dep't of Letters (as we may call it) standing back of the publications in the character of a subsidizer. The writers to be paid for sustenance while writing. And again, quality of writing should be the objective. Prizes might be offered in the form of republication on a national scale. And to the publishing houses.

Wonders might come from such a move as you propose, for letters are the wave's edge in all cultural advance which, God knows, we in America ain't got much of.

Sincerely yours

9 Ridge Road, Rutherford, N.J. William Carlos Williams

4
Letter from William Carlos Williams to Edward B. Rowan,
August 28, 1934
National Archives, Records of the Public Buildings Service

wages amounting to about $38–$46.50 a week. In addition to the Coit Tower murals that Ruth Zakheim described, PWAP workers produced about 400 other murals along with 6,800 easel works, 650 sculptures, and 2,600 print designs. But during its brief life, the CWA supported other art forms as well. A CWA opera company toured the Ozarks; in New York City, CWA actors put on marionette theater and vaudeville for the city's hospital patients and schoolchildren; and in Cleveland, Ohio, CWA writers wrote publicity for and conducted research on the history of local social service agencies. Such projects undoubtedly allowed artists to survive what was an especially harsh winter, but they also restored self-respect and permitted an outlet for creativity. "I have a new outlook on life," wrote one PWAP artist to Edward Bruce. "A future that looked so dark and hopeless just a short while ago has changed completely." Another wrote that the PWAP provided "not only desperately needed funds, but hope and a feeling of being included in the life of my time."

Despite such testimonies, FDR believed the CWA was too expensive and, fearing that its continuation would create a permanent class of relief recipients, he ordered it ended in the spring of 1934. But Treasury Department officials believed their program had been a success, and with unemployment still at high levels, they remained committed to a program that would employ artists. In August, Edward B. Rowan, who had been Assistant Technical Director of the PWAP, wrote to well-known individuals working in the arts to ask for their suggestions. A few expressed reservations. For example, the journalist H. L. Mencken voiced his fear that "if you begin to offer subsidies to writers they will all go to quacks" (fig. 5). But others, including writers Conrad Aiken and Theodore Dreiser, poet

William Carlos Williams, dramatist Elmer Rice, theater critic Brooks Atkinson, and conductor Leopold Stokowski, responded more positively. Atkinson and Rice suggested traveling theatrical repertory companies, while Dreiser and Aiken urged that the government publish a series of federal literary magazines. Stokowski recommended that the government "pay American composers for their work and give them an opportunity of hearing their work played publicly." Williams hoped for a National Department of Letters but worried that the public would consider it "too radical in thought for countenance by the government" (fig. 4).

By early 1935 Roosevelt was again poised to experiment with yet another work program. Declaring that "the Federal Government must and shall quit this business of relief," in January he proposed an enormous and comprehensive public works program that would "preserve not only the bodies of the unemployed from destitution, but also their self-respect, their self reliance, and courage and determination." In April, Congress passed the Emergency Relief Appropriation Act and gave FDR broad discretionary powers to spend almost $5 billion on work projects. In May, Roosevelt used this power to create the Works Progress Administration (WPA), once again asking Harry Hopkins to

5

Letter from H. L. Mencken to Edward B. Rowan, August 30, 1934

National Archives, Records of the Public Buildings Service

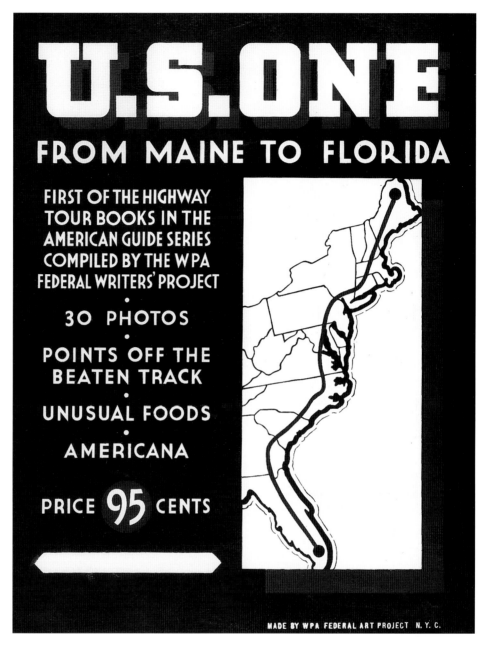

6
"U.S. One From Maine to Florida"
Poster by the New York City Federal Art Project,
1938
Silkscreen
National Archives, Records of the Work
Projects Administration (69-GP-3)

run it. In August, Hopkins created WPA Federal Project Number One, which designated money for federal art, theater, music, and writing projects. Commenting on criticisms that the federal government had no business supporting the arts, Harry Hopkins replied that artists needed jobs as badly as the rest of the work force. "Hell!" said Hopkins, "they've got to eat just like other people."

Soon Uncle Sam was running a variety of programs that gave work to thousands of writers, painters, musicians, actors, photographers, and dancers. The WPA projects were the largest and justifiably the most famous of

these. The Federal Writers', Theatre, Art, and Music Projects hired individuals, most of whom had to qualify beforehand for relief, to work at their craft for an hourly wage usually amounting to a maximum of about $100 a month in a large city like New York. To run the projects, Hopkins tapped talented and committed individuals: conductor Nikolai Sokoloff led the Music Project; Hallie Flanagan, of Vassar College's Experimental Theatre, directed the Theatre Project; Holger Cahill, a museum professional and expert in folk art headed the Art Project; and journalist Henry Alsberg steered the Writers' Project. All

the WPA projects got under way in 1935 and, with the exception of the Theatre Project, which Congress ended in 1939, continued until 1943.

While the largest projects were centered in cities, especially New York and Chicago, the WPA art projects were truly nationwide in scope. There was WPA theater not only in New York City but in San Diego, California; Des Moines, Iowa; Portland, Oregon; and Omaha, Nebraska. Traveling theater units visited smaller towns. Community art centers were opened in places as different as New York City's Harlem; Melrose, New Mexico; and Spokane, Washington. The Writers' Project's American Guide, a series of state, regional, and city guides, covered all 48 states and communities such as Ringgold County, Iowa; Salina, Kansas; and Beaumont, Texas. The Music Project sponsored thousands of concerts and music festivals featuring WPA orchestras, bands, and vocal groups across the country.

By the time they ended, the WPA arts projects could point to numerous accomplishments, some of which made lasting contributions to American life and culture. Of the Federal Writers' Project's (FWP) approximately 1,200 publications (fig. 6), many of the volumes in the American Guide series remain classics, the first attempt at comprehensively describing the history and culture of the 48 states for a popular audience. Over its existence, the FWP writers created 14,000 manuscripts. Project staffers collected a variety of

urban and rural folklore, slave narratives, ethnic "life histories," and "work histories." Some of these made up the raw material for books such as **The Negro in Virginia** and **The Italians of New York,** but many other manuscripts remain unpublished and now rest in archives and libraries where they continue to be consulted by historians, folklorists, and anthropologists. Other FWP workers wrote children's books and technical pamphlets and compiled newspaper indexes. Notable authors who worked for the project include Richard Wright, Ralph Ellison, Zora Neale Hurston, Saul Bellow, Studs Terkel, Conrad Aiken, and John Cheever.

Among the Federal Theatre Project's (FTP) most original creations were the "Living Newspapers," which dramatized contemporary social and political issues such as slum housing, industrial relations, electric power, and venereal disease. The FTP sponsored regional and community theater that produced Shakespeare, Shaw, and Marlowe as well as vaudeville and a variety of children's plays (fig. 9). It organized Negro, Yiddish, and Spanish-speaking units. Its innovative all-black "voodoo" **Macbeth** was set in Haiti at the time of the rebellion against the French, staged in Harlem, and directed by Orson Welles. **The Cradle Will Rock,** a controversial opera set around a steel strike, featured music by Marc Blitzstein. Welles also directed, starred, and even designed some of the costumes for a notable production of **Dr. Faustus** that played to packed New York City houses

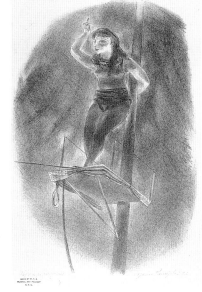

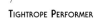

7

Tightrope Performer
By Yasuo Kuniyoshi
Lithograph
Franklin D. Roosevelt Library, National Archives and Records Administration (MO 56-263)

8

INDIAN HUNTERS AND RICE GATHERERS
[Study for Post Office Mural in St. James,
Minnesota]

By Margaret Martin, Treasury Section of Fine Arts,
1940
Oil on tracing paper
National Archives, Records of the Public
Buildings Service (121-GA-37-Martin-1)

for months (fig. 121). In addition to Welles, John Houseman, E. G. Marshall, Burt Lancaster, Arthur Kennedy, John Huston, and Arthur Miller all worked for the FTP.

The Federal Music Project (FMP) supported not only symphonic orchestras but also dance bands, choral groups, and chamber ensembles. By 1939 it employed 7,000 musicians and had sponsored some 225,000 performances that had been seen by 150 million people. It presented the compositions of promising Americans in "Composer Forums," where the merits of new works by composers such as Aaron Copland and William Schuman were performed, discussed,

and debated (fig. 10). Music Project workers collected folk music, offered music classes, copied music, repaired instruments, and worked as music librarians. The FMP also began an Index of American Composers, which, though never completed, is now held by the Library of Congress and contains the names, titles, and biographical information of more than 2,000 composers.

The fourth WPA project, the Federal Art Project (FAP), gave work to painters, sculptors, graphic artists, and art instructors. Its 5,000 artists created some 108,000 easel paintings, 17,700 sculptures, 11,200 print designs, and 2,500 murals (fig. 7). FAP artists

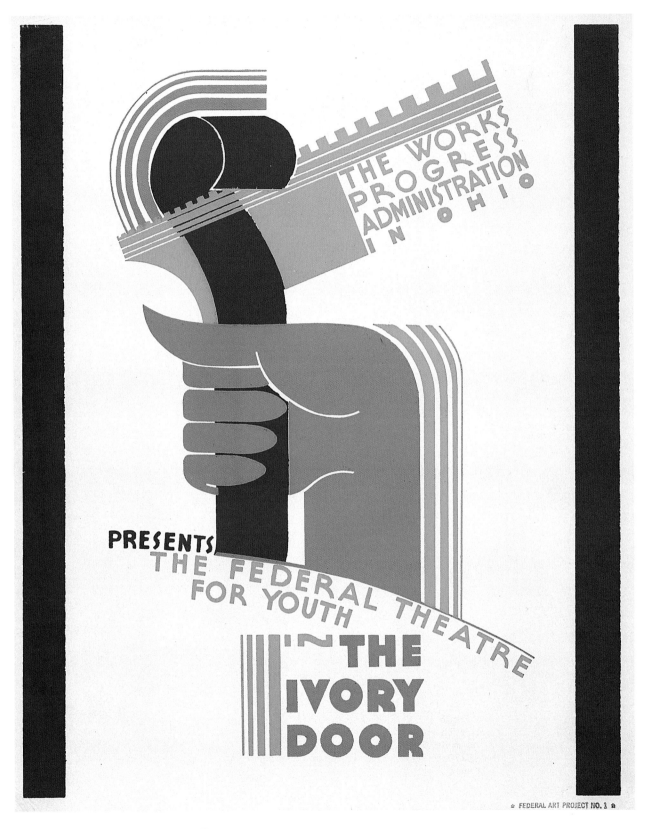

9

Poster for THE IVORY DOOR

Art by the Ohio Federal Art Project, WPA, 1938

Play by the Ohio Federal Theater Project, WPA, 1938

Silkscreen

National Archives, Records of the Work Projects Administration

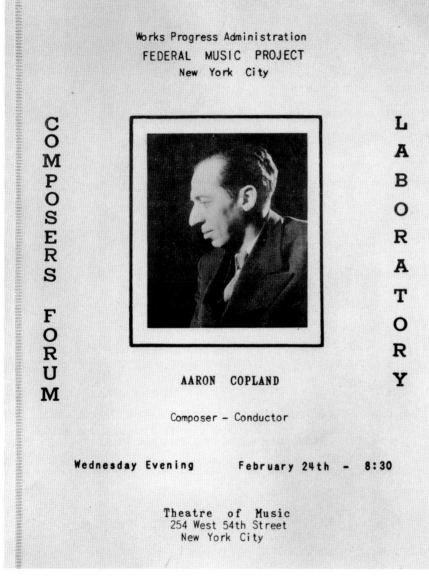

Works Progress Administration
FEDERAL MUSIC PROJECT
New York City

C O M P O S E R S F O R U M

L A B O R A T O R Y

AARON COPLAND

Composer – Conductor

Wednesday Evening February 24th - 8:30

Theatre of Music
254 West 54th Street
New York City

10
Program from "Composer Forum" featuring Aaron Copland, New York City Federal Music Project, WPA, February 24, 1937

National Archives, Records of the Work Projects Administration

are especially credited with advancing the printmaking medium and adapting the silkscreen process to allow for the mass production of posters. Another FAP program, the Index of American Design, compiled "a pictorial survey of American design in the American decorative, useful, and folk arts from their inception to about 1890." Art Project employees also ran community arts centers, gave drawing and painting lessons, worked as model makers, and coordinated a travel-

ing exhibition program. Well-known visual artists who worked for the FAP include Yasuo Kuniyoshi, Jack Levine, Raphael Soyer, Arshile Gorky, Jacob Lawrence, Stuart Davis, and Jackson Pollock.

But the large size and scope of the WPA projects has allowed many people to erroneously label all New Deal art "WPA art" and obscures the many non-WPA New Deal arts endeavors. It is important to remember that several other government departments sponsored additional art projects. Among the most enduring and familiar legacies of the New Deal, for example, are the hundreds of post office murals located across the nation (fig. 8). These murals were done not by the WPA but by artists working for the Section of Painting and Sculpture (later called the Section of Fine Arts), a part of the Treasury Department. The Section, which was led by Edward Bruce, Forbes Watson, and Edward Rowan, selected artists for its murals on the basis of open competitions announced in its **Bulletin,** with winners chosen by juries of distinguished judges who were themselves artists. Unlike WPA artists, who received an hourly wage, Section artists were commissioned and paid for completing a work in a specific post office or federal building.

The New Deal programs were also in large part responsible for making the 1930s the golden age of documentary photography. The largest and most famous of these government-sponsored documentary projects were sponsored by the Agriculture Department, especially the Resettlement Administration (RA), which later became the Farm Security Administration (FSA). Together, these two projects produced 66,000 black-and-white photographic prints, 122,000 black-and-white negatives, and about 650 color transparencies—all of these images depicting the life of the nation between

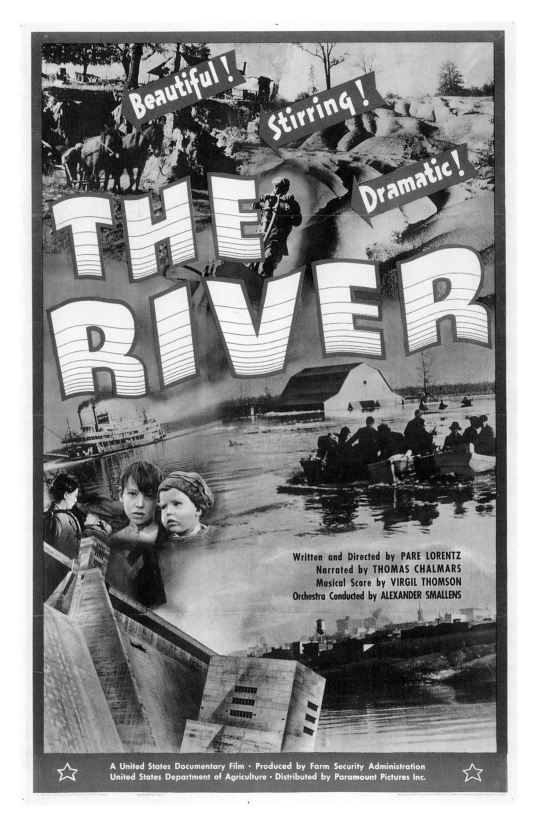

11
Poster for THE RIVER
Film by the Resettlement Administration
By Paramount Pictures, 1938
Photolithograph
National Archives, Records of the Farmers Home Administration
(96-P-1)

12
**From the "Along the Waterfront" series. New York City,
January 3, 1937**
By David Robbins, New York City Federal Art Project, WPA
National Archives, Records of the Work Projects Administration
(69-ANP-13-P759-70)

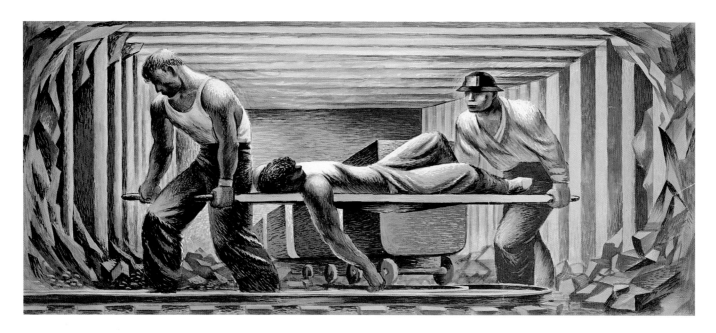

1935 and 1942. Other agencies including the WPA, the Bureau of Agricultural Economics, the Rural Electrification Administration, and the Civilian Conservation Corps sponsored smaller photography projects (fig. 12). Dorothea Lange, Walker Evans, Russell Lee, Ben Shahn, John Vachon, Marion Post Wolcott, and Arthur Rothstein were among the accomplished photographers who worked for the federal government during the 1930s and early 1940s.

For a time, the federal government even went into the movie-making business. It used government-produced documentary films to expose the social problems of the Great Depression and to build support for New Deal plans to solve them. Pioneering filmmaker Pare Lorentz's work for the Resettlement Administration and, later, the United States Film Service resulted in such classics as **The River** (fig. 11), which explained the need for flood control, and **The Plow That Broke the Plains,** which dealt with the need for soil conservation. **The Fight for Life** uncovered poor urban health conditions, while **Power and the Land** demonstrated the benefits of

rural electrification. Some 60 years later, aspiring documentary filmmakers still study these works.

But while they could boast of many accomplishments, the art projects had their share of problems. The origins of many of these difficulties, especially within the WPA, can be traced to the inherent tensions stemming from a government bureaucracy employing creative individuals. Painters, composers, actors, writers, and other artists are not usually noted for their regular hours or their ability to suffer rigid regulations gladly. Yet the WPA's model for hourly employment was drawn from the routinized world of industry. Project personnel were expected to sign in and out and to work in a centralized location under the watchful eyes of a timekeeper. Federal Theatre Project rehearsals often started late in the morning or went on late into the night, a practice that played havoc with WPA timekeeping. FSA and other government photographers were sometimes required by agency regulations to send their film to Washington, DC, for processing, a practice that many strongly opposed. For a

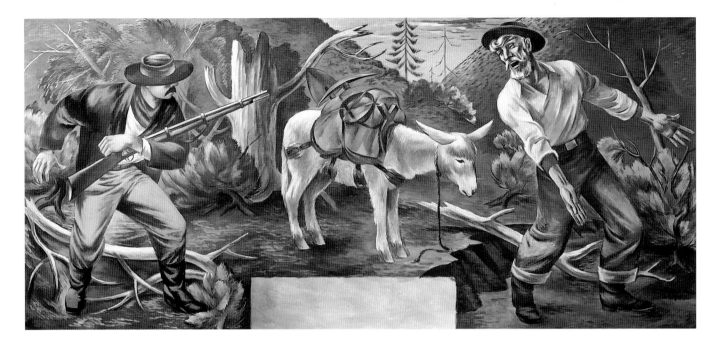

14
DISCOVERY
By Fletcher Martin, Treasury Section of Fine Arts, 1940
National Archives, Records of the Public Buildings Service
(121-PS-7597)

time, Holger Cahill convinced WPA head Harry Hopkins to allow the painters, sculptors, and printmakers under his charge to work on their own schedule and at their own studios under an honor system. But WPA state administrators were aghast at this experiment, and most state projects eventually returned to the more inflexible system.

Political pressures of several sorts also vexed the projects. On the political left, unions such as the American Artists Union organized WPA artists and lobbied for expanding the projects. They resisted wage cuts, personnel reductions, and the imposition of what they considered petty bureaucratic rules on project employees. For these activist artists, the projects were more than a source of employment. They represented an opportunity to recruit members and promote

political causes such as supporting the plight of southern tenant farmers or striking industrial workers. Such political activity was common in the 1930s, but it led to a backlash from conservatives, especially Republican Members of Congress, who claimed the projects were "red nests" filled with Communists. Though the number of actual Communist Party members was small, the radical activities of project staff gave ammunition to those on the right seeking to abolish the projects.

Controversies about content also plagued the projects. Federal Theatre Project productions were sometimes canceled when politicians or community groups were offended by scripts they considered radical or obscene. An early FTP production, **Ethiopia,** was canceled at the request of the White House because it addressed the touchy issue

of the Italian invasion of Ethiopia. Audience members attending the melodrama **Big Blow** hissed during a scene in which a white female cast member threw her arms around a black actor. In Chicago, the play **Model Tenement,** which dealt sympathetically with a rent strike, was shut down by the head of the city's WPA. The complaints about the production had come directly from the mayor's office.

Other projects were not immune from political pressures. A tourism trade association urged that WPA guide books be inspected for "efforts to tear down traditional heroes and popular legends." The Springfield, Missouri, Chamber of Commerce objected to the portrayal of the Ozarks in an American Guide publication because it "played up the delinquencies" of the region. When the Treasury Section installed Romuald Kraus's bronze **Justice** in the courtroom of Judge Guy L. Fake of Newark, New Jersey, Judge Fake objected vehemently to the female figure with upraised arms. Where the panel awarding the commission saw compassion, he saw "a picture of brute force" and "a spirit of ruthless confiscation" that "smacks blatantly of communism."

The Treasury Section's program of embellishing post office lobbies with murals was especially sensitive to criticism from local citizens. The Section wanted very much to please the towns where its murals were to be installed, and they were extremely attentive to local reaction. For example, residents of Paris, Arkansas, objected to the proposed mural for their town by Joseph Vorst because they felt it played to stereotypes of Arkansans as ignorant and mired in rural poverty. Eventually, they got a mural showing prosperous farmers with up-to-date equipment and well-maintained buildings.

Another more publicized flap occurred

when Fletcher Martin won the competition to paint a mural for Kellogg, Idaho's, new post office. The jury that awarded the commission praised his design for **Mine Rescue** (fig. 13). Unfortunately, many citizens of Kellogg did not agree, and a number of them wrote to Washington, DC, protesting the award. They argued that the mural was unfit for a mining community because its subject—two miners carrying an injured worker out of a mine on a stretcher—would pain those who had lost a loved one in an accident. Government officials initially insisted on Martin's design but eventually asked him to redesign the mural after soliciting suggestions from the community. His inoffensive substitute, **Discovery** (fig. 14), shows two excited prospectors at the moment they discovered a local mine.

Local officials were not shy about suggesting changes to their murals or critiquing an artist's view. After Joe Jones received the commission to paint a mural for the Seneca, Kansas, Post Office, he produced a color sketch, **Men and Wheat,** that showed two farmers at work on a tractor and a combine in the midst of a Kansas wheat field (fig. 15). When photographs of the sketch were published in Seneca, the town's postmaster, W. Kauffman, wrote to Jones complaining that the scene did not reflect the geography and architecture of northeast Kansas and that the machinery should not have a brand name so prominently displayed (fig. 16). Jones fought the changes, arguing that "postmasters are never typical in their community" and charging that the proposed modification amounted to "a neat destruction of content," but eventually he altered the mural's background to a scene more typical of the region and blurred the name on the machinery to mollify Seneca's postmaster.

Such controversies and problems provide fascinating glimpses into the workings of

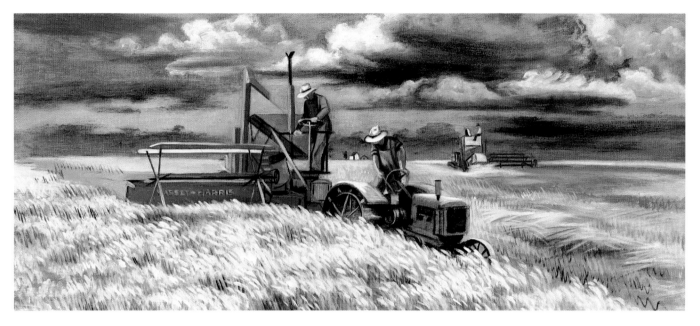

15

MEN AND WHEAT

By Joe Jones, Treasury Section of Fine Arts, 1939
Oil on canvas
National Museum of American Art, Smithsonian
Institution, transfer from the U.S. Department of
the Interior, National Park Service (1965.18.5)

the various New Deal projects and their inter-action with various audiences. By focusing on such examples, it is tempting to conclude, as have some historians, that the projects, espe-cially the Section, was heavy handed in its approach to its artists, imposing the aestheti-cally mundane, the trite, and the tired on artists or that they too easily buckled to polit-ical pressure. The reality was more complex. The projects were bureaucracies, but they were generally humane ones. Many art ad-ministrators were artists themselves who were remembered fondly by those they super-vised, who tried to allow artists as much free-dom as possible, and who would try to fight political interference. Artists, especially younger, less experienced ones, usually wel-comed the advice their supervisors or the Section juries offered.

Admittedly, the range of art taken on by the projects was limited, and the quality of the art they produced was uneven. The pri-mary purposes of the projects, after all, were to provide relief and to allow artists to main-tain their skills. For every pathbreaking work of the Federal Theatre such as the innovative

"Living Newspapers," the imaginative "voo-doo" **Macbeth,** or the popular **Swing Mika-do,** there was much more standard fare, some of it, no doubt, dreadful. Accounts of the various projects are filled with stories of inept or long-in-the-tooth individuals passing themselves off as actors, writers, artists, or musicians so they could receive relief pay-ments. Editors with the FWP were kept busy rewriting copy produced by some of the pro-ject's less skilled "writers." Today, some of the murals commissioned by the Section seem amateurish, hackneyed, or occasionally even bizarre.

But the projects' shortcomings need to be measured against their many accom-plishments. First among these was the fact that many artists could not have survived the Depression without them. "For the first time in our history," wrote George Biddle, "the Fed-eral Government has recognized that it has the same obligation to keep an artist alive. . . as to keep a farmer or carpenter alive." Many artists never forgot their first WPA pay-check. In her autobiography, Anzia Yezierska remembered the mood of her colleagues

on the New York City FWP "as hilarious as slum children around a Christmas tree. . . . Men who hadn't had a job for years fondled five and ten dollar bills with the tenderness of farmers rejoicing over a new crop of grain." And even if it is true that the New Deal programs produced no true masterpieces, a government program that supported creative individuals as diverse as Ralph Ellison, Richard Wright, Jackson Pollack, Studs Terkel, Burt Lancaster, Ben Shahn, and Zora Neale Hurston is not only pathbreaking but must be considered as having a positive and lasting influence.

And the projects were more than simply a humane response to individuals in need. Artists remembered their time working for them as creative as well as life sustaining. The painter Anton Refregier recalled his years on the WPA as "the most meaningful and happiest of my life." He "felt a sense of purpose" and a "close comradeship among the artists." Edward Laning, a WPA muralist, gushed, "We were doing what we most wanted to do and getting paid a living wage to do it. It was a glorious time!" Hopkins and FDR's farsighted decision to include creative endeavors among the New Deal's public works saved many artists not only from the relief line but also from being forced to abandon their creative work.

The arts projects also served as a training ground for new talent, as a chance for established artists to maintain their skills, and, within limits, as a place where artists could experiment with subjects and techniques. The actor E. G. Marshall said that he "might not have made it if it hadn't been for the Federal Theatre. . . . Others like me, directors and so on, got their first chance." FAP graphic artist Anthony Velonis credited the projects with "rescu[ing] a generation of artists to become productive citizens rather than cyni-

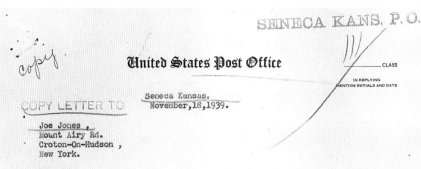

16
Letter from W. Kauffman to Joe Jones, November 18, 1939
National Archives, Records of the Public Buildings Service

cal revolutionaries." Even artists who later abandoned the realism favored by the projects remembered them as a positive force. Abstract artist Joseph Solman argued that "the abstract-expressionist movement is unthinkable without the encouragement to survive and experiment that was given these artists by the WPA."

Beyond these individual stories are the projects' contributions to American society. These cannot be measured merely by the thousands of murals, paintings, sculptures, or prints the projects produced or by the thousands entertained, enlightened, or challenged by their performances. Although America was greatly enriched by the presence of this art, the projects' most important contribution was in demonstrating and including the enormous breadth of American culture in their many activities. The projects touched millions of people in all sections of the country not only through the display and performance of art but through art and music classes, community arts centers, and community theater and dance. They encompassed and included a variety of ethnic groups that had gone largely unnoticed by many in the professional arts community. In addition to supporting a variety of traditional ethnic theater, writing, and art, they sparked new interest in African-American theater, Native American arts and crafts, Appalachian music, and Hispanic influences on American design. The projects also strongly supported women artists.

Such inclusiveness and breadth were the projects' most lasting gifts to 20th-century American culture. In the words of two historians, government-sponsored art "extended democracy into the cultural sphere." There are many examples of this cultural democratization. The ballet **Frankie and Johnny** introduced folk idioms into the classical repertoire.

The local and social histories in the Federal Writers' Project's American Guide series were immensely popular, and its work and life histories continue to be valuable resources today. The Index of American Design painstakingly reproduced American folk art from several traditions. The Federal Theatre gave voice to a broad range of social concerns including controversial topics like housing, prison conditions, and racial discrimination. Undoubtedly, the projects could have done more. Section administrators, for example, could have been as aggressive in finding commissions for black artists as they were for Native Americans and women. But such criticisms should not blind us to appreciating the impact of the projects on the Depression-era artists or on those who witnessed their creative efforts. The paintings, prints, books, playbills, posters, and music transcriptions these efforts produced are more than the artifacts and documents of a largely forgotten emergency work program. They are examples of an extraordinary burst of American creativity that occurred during a time of tremendous change and trial.

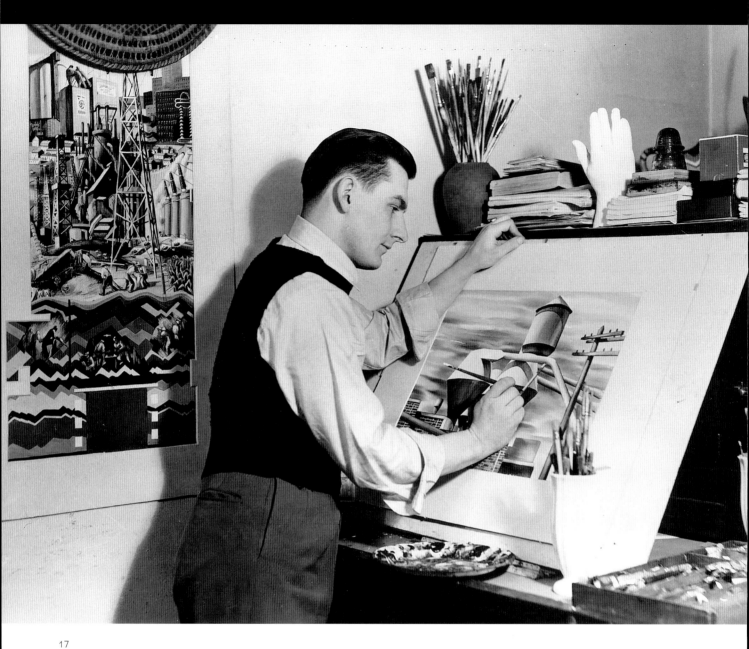

17

"WPA artist Edmund Lewandowski of Wisconsin
working in his studio"

By an unknown photographer, May 19, 1939

National Archives, Records of the Work Projects Administration

(69-AG-403)

THEMES IN NEW DEAL ART

While their activities varied, the arts projects, and those who ran and supported them, shared many of the same goals. Foremost among these was a belief that the projects had the potential to be much more than a means of providing emergency employment. If nurtured properly, the projects could help to foster what one historian has labeled "cultural democracy." In such a society, art would be available not just to the monied few but to all. Works of art would no longer be for rich collectors or seen only, in FDR's words, "in a guarded room on holidays or Sundays." Instead, they would be "in school houses, in post offices, in the backrooms of shops and stores" across America. Theater, too, would be transformed into what Hallie Flanagan called "a people's theatre." It would produce "free, adult, and uncensored" plays of significance that would appeal to working class and ethnic audiences because they confronted pressing social issues. Even music could have a democratizing effect. Before the WPA, wrote V. F. Calverton, music had been "confined to the Classes and not to the masses. Thanks to the WPA Music Project . . . that is no longer the case."

The arts projects could also help bring about a renaissance in American art. This modern renaissance would not necessarily produce individual masterpieces. Emphasis on great works, according to Holger Cahill, was "a nineteenth century phenomenon" anyway. Instead, New Deal America would see "a great reservoir of art," where art and artist were embraced by society and where entire populations would not only appreciate, but participate in, its creation. The WPA/FAP community arts centers and the mural works of the WPA and Treasury Section

are good examples of Cahill's "genuine art movement." In the art centers, people from all walks of life took painting, sculpture, or printmaking classes; saw exhibits; and heard lectures on art. Murals not only introduced art to many Americans for the first time, but this public art would "belong to the community," serving as "a vital integrated expression of today, giving a permanence to our own time."

The belief in the need for a rebirth of American art was best articulated by, but not limited to, Cahill. Hallie Flanagan, the director of the FTP, argued that the theater was on the verge of becoming "a museum product," irrelevant to contemporary society, still "whispering its tales of triangular love stories in small rectangular boxes." She envisioned regional and local theatrical companies across the country energetically addressing the needs of their communities so that the average American could "turn the . . . social and economic forces of our time toward a better life for more people." Henry Alsberg felt encouraged that much of the writing under his direction held "little echo of higher aestheticism or the delicate attenuations of emotions." Instead it came "from the roadside ditch, the poverty stricken tenement . . . the relief station." Such realism, he believed, moved literature squarely into the life of its time.

Finally, the projects, it was argued, were transforming society's notion of the artist and his or her relationship to society. Before the New Deal, artists had been isolated from the mainstream of American life. Many Americans, when they thought of artists at all, considered them "an ornament of the pink tea" or "the playboy companion of the dilettante

patron." The Depression and arts projects changed all that. The economic crisis forced the artist to see himself or herself as a worker, whose interests were largely the same as those on the assembly line or in the steel mills—"a workman among workers." This shift was the first step toward reintegrating the artist into American society. The arts projects supplied the means to that end. They asked artists of all types to embrace subjects that were native, understandable, and meaningful to most Americans. According to social critic Lewis Mumford, "artists . . . have been given something more precious than their daily bread: they have at last achieved the liberty to perform an essential function of life, in the knowledge that their work had a destination in the community."

Beyond these general goals, most New Deal art followed several more specific themes. The following sections outline five of these: the projects' use of American history, their celebration of the common man and woman, their support for the New Deal, their political activism and the art that was a product of these concerns, and their sponsorship of "socially useful" or "practical" arts. These themes are not all-inclusive; there were New Deal arts endeavors that do not fall into any of these categories—abstract painting, for example. Also, artists and individual works of art often crossed over these thematic lines. An artist such as Raphael Soyer concentrated on the lives of anonymous people, but his art has a strong social realist look, and much of it could be placed in that section. A Federal Theatre production such as the historical drama **Prologue to Glory** also tells the story of Abraham Lincoln, the common man. The Index of American Design is an example of a "socially useful" project; it is also testimony to the decade's interest in the American past. The five themes are not intended to be lim-

iting but to represent a broad spectrum of New Deal art undertakings.

Likewise, this organization of text does not intend to separate New Deal art from the more general themes of American culture in the 1930s and 1940s. Visual arts categories such as American Scene painting and social realism have broader application than to just the New Deal projects. Left-wing theater was not limited to New Deal productions such as **The Revolt of the Beavers** or **The Cradle Will Rock.** Outside the FTP, playwrights such as Clifford Odets also explored radical and labor-oriented themes.

Of course, the major difference between the New Deal arts projects and non-federal art was just that: the arts projects were directed and supported by the government. Before the New Deal, art was for the most part firmly planted in the private sphere. The Depression challenged this assumption, and the projects provided a challenge to this arrangement. For this reason the projects represent a major departure in the history of the arts and their relationship to the American state. While they failed to become a permanent part of the American scene, they did change the way our society looks at supporting culture. And while we are not likely to see support on the scale of the New Deal projects again, their less robust, but still controversial, descendants survive in the National Endowments for the Humanities and Arts, the Art and Architecture program of the General Services Administration, the Corporation for Public Broadcasting, and other federally supported cultural institutions.

R *e d i s c o v e r i n g A m e r i c a*

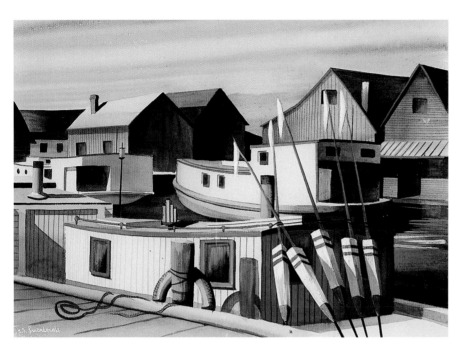

18

FISHERMEN'S VILLAGE

By Edmund Lewandowski, Wisconsin Federal
Art Project, WPA, 1937

Watercolor and gouache over pencil on paper
Franklin D. Roosevelt Library, National Archives
and Records Administration (MO 56-332)

In part, the answer can be found in the social chaos caused by the Great Depression. While there were some who called for radical change, and even a few who predicted a Soviet-style revolution, most Americans of the 1930s responded to the economic disaster less with revolutionary fervor than with quiet stoicism. In art likewise, during the Depression many artists chose to concentrate on the promise of American life, on the uniqueness of the American experience, and on the ideals and values that had allowed democracy to endure past challenges rather than on promoting a rush to the barricades.

Even before the Depression, strong national and regionalist arts movements were already flourishing. In painting, this drive was most closely identified with the work of "regionalists" such as Grant Wood, Thomas Hart Benton, and John Steuart Curry. In literature, "Southern Agrarians" such as Allan Tate, John Crowe Ransom, and Robert Penn Warren argued for regionally based writing. In music, composers such as Aaron Copland, Ferde Grofé, and Virgil Thomson

Artistic nationalism was a prominent aspect of much New Deal art. This interest in things American took many forms: muralists painted scenes depicting local history and color; folklorists recorded traditional stories; playwrights created plays about American heroes; photographers documented daily

> *"I am a photographer hired by a democratic government to take pictures of its land and its people. The idea is to show New York to Texans and Texas to New York."*
>
> —Russell Lee, FSA photographer, **U.S. Camera One**, 1941

life; and writers produced state, regional, and local histories. At first glance, this turn toward Americana may seem paradoxical. Why, at a time when the United States was in the midst of its greatest crisis since the Civil War, at a time when some doubted that the Republic would survive, would a variety of artists choose to concentrate on such home-grown themes? Why this renewed interest in American history and culture?

incorporated American folk songs and hymns into their scores. It was often argued that the arts in America had become slaves to European content, style, and technique and needed their own voice. The art critic Thomas Craven put forward this view in the strongest of terms: "Again and again I have exhorted our artists to remain at home in a familiar land, to enter into strong nativist tendencies, to have done with alien cultural fetishes."

In the visual arts, the creation of the federal arts projects coincided with the popularity of the movement known as the "American Scene." American Scene artists were especially interested in regional and small-town life and produced views of local color and straightforward celebrations of ideals such as community, democracy, and hard work. Although the arts projects did not force artists to work in one style, the American Scene became the unofficial style of the projects—especially in public works such as murals. Artists aimed at producing views that would connect their paintings with the populace. "Art," stated a WPA description of project activities, must "speak a language which is directed to the people and comprehensible to them."

This type of art was easily understood, appreciated by a large numbers of Americans, and relatively uncontroversial. It was also self-consciously American, finding inspiration not in the work of European masters or training overseas but in "the life and landscape outside the painter's door." These attributes were particularly appealing to those who directed the New Deal projects

and who were ultimately dependent on the taxpayers for continuing their programs. Edward Rowan, the assistant head of the PWAP, stated this view succinctly. Project directors expected "that the American Scene be stressed" in its painting. Those artists who could only paint "foreign subject matter" should be dropped from the rolls in favor of those "with the imagination and vision to see the beauty and the possibility for aesthetic expression in the subject matter of his own country." Rowan was never this harsh or inflexible in practice, but his comments do emphasize the American Scene's place within the PWAP hierarchy of styles.

Many American Scene paintings deal with historical subjects presented nostalgically. Paul Kelpe's **History of Southern Illinois** is a good example (fig. 19). Done for the library at Southern Illinois University at Carbondale for the WPA, the mural portrays the 19th-century industry, agriculture, and commerce of the region. A large panel depicts a group of men working energetically at variety of tasks: plowing a field, sawing wood, and carrying freight unloaded from two riverboats shown prominently in the background.

19 (Above and opposite)
HISTORY OF SOUTHERN ILLINOIS
By Paul Kelpe, Illinois Federal Art Project, WPA, ca. 1935–39
Gouache on paper
Franklin D. Roosevelt Library, National Archives and Records Administration (MO 56-331)

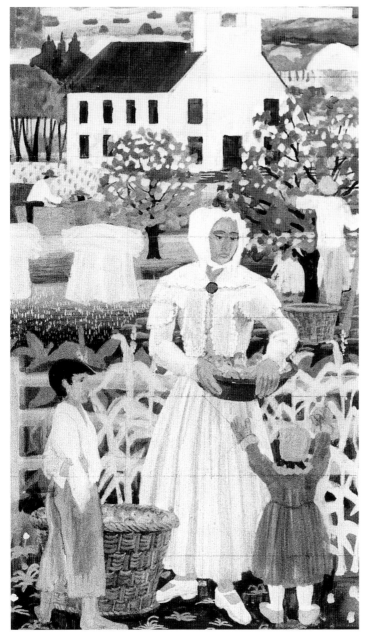

In a smaller panel, a woman pauses from her work in the garden to acknowledge two small children. In the background of this panel are three men hard at work in an orchard and a building that could be either a church or school.

Kelpe's work, like many New Deal murals in the style of the American Scene, hearkens back to a supposedly simpler time when Euro-American pioneers had triumphed over adversity and built the nation through hard work, community, courage, and strength of character. The results of all this industry—the growing fields, the commerce on the river, the school or church, even the children—are offered as proof that progress and community were achieved despite frontier conditions. Implicit is the lesson that current difficulties can be overcome. The presence of a single marginalized black figure, stereotypically posed eating a watermelon, was probably intended to add to the mural's "local color," but it, too, reinforces the artist's theme that American history was built around hard work and perseverence of the majority culture.

American Scene painting was not limited to historical subjects. New Deal printmakers and painters drew on the local color of American communities. Unlike Kelpe's mural, Edmund Lewandowski's picturesque watercolor **Fishermen's Village** does not deal with a historical theme, but it shares a nostalgia for small-town life and simpler times (figs. 17, 18). Lewandowski's waterfront is a snapshot of life that seemingly stands apart from the context of Depression America. Ceil Rosenberg's untitled urban scene completed under the PWAP is a good illustration of the American Scene adapted to an urban context (fig. 20). Rosenberg's painting shows a city (probably Chicago) just after a snowfall. The new snow softens the harsh edges of the city, and the artist's focus is on smaller scale neighborhood buildings rather than on the misty factories and skyscrapers in the distance.

While the arts projects never forced artists to work in one fashion, the American Scene became their unofficial style, especially in public works such as post office murals. Post office muralists working for the Treasury Section were expected to go to the town where their commission would be displayed, soak up the town's history and color, and seek suggestions about themes from the locals. This help was often welcomed by

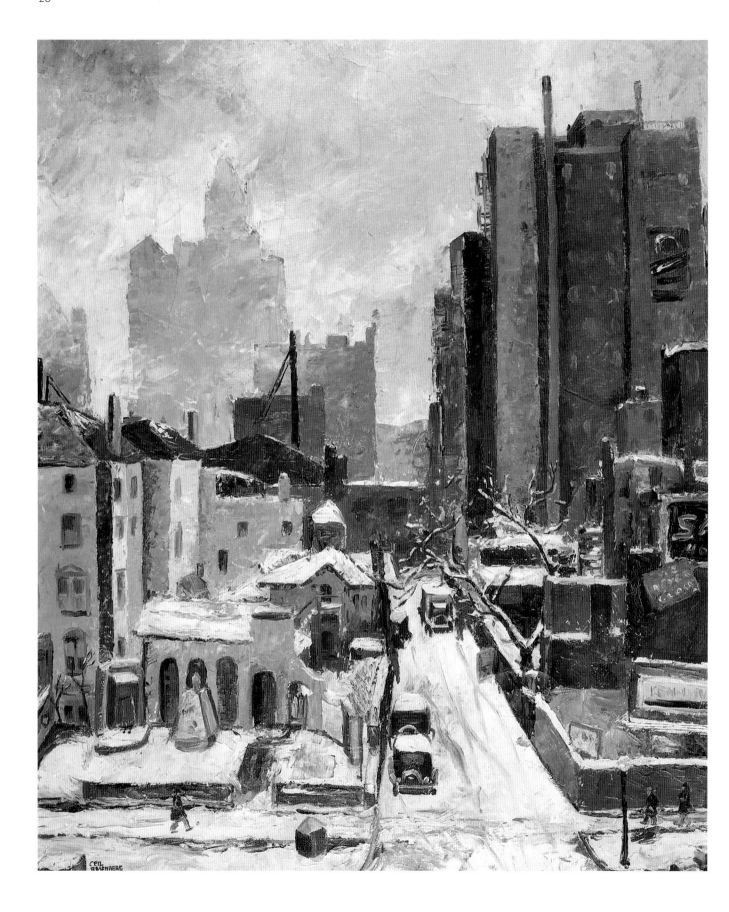

21
BAND CONCERT
By Marion Gilmore, Treasury Section
of Fine Arts, 1939
Tempera on fiberboard
National Museum of American Art, Smithsonian
Institution, transfer from the General Services
Administration (1974.28.344)

artists, especially if they were working in a region unknown to them. But the interplay among artist, townspeople, and government administrators could be a delicate one. Artists sought to preserve their creativity and freedom. Local citizens often had strong ideas about style or content. Administrators tried to allow artists the freedom to create, but they

Edward Rowan, who was an Assistant Chief with the Section, asked Gilmore how she had incorporated scenes of Corning into her mural. She revealed that several of the details in her entry were drawn from towns other than Corning. Rowan, shocked and worried that Corning's residents would object, insisted that Gilmore paint a truer depiction

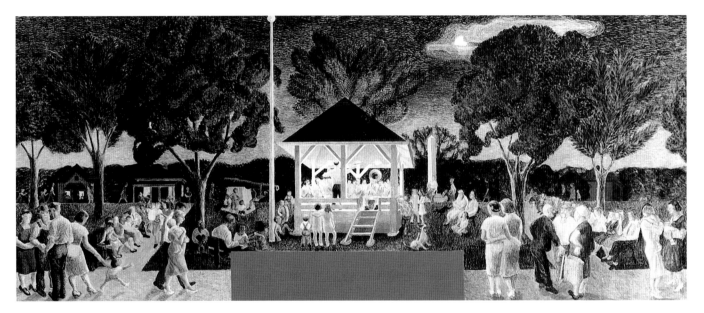

also considered the public their "patron" whose wishes "should be given full consideration."

The story of the mural for Corning, Iowa, points out just how sensitive Section officials could be about deviations from public desires, real or imagined. Marion Gilmore received the commission to paint the mural for the Corning lobby by submitting a winning design to the 1939 "Forty-Eight States" competition sponsored by the Section. Her winning entry, entitled **Band Concert**, was very much an American Scene painting, showing a crowd gathering for an evening summer concert at a bandstand on a quaint town square (fig. 21). In the background, Gilmore's sketch showed a cannon and an obelisk. After the commission was awarded,

of Corning. In the completed mural, the bandstand was altered and the obelisk and cannon eliminated.

The PWAP and Section discouraged art that was abstract, controversial, or swayed by foreign influences. Rowan argued that while government artists should be given "the utmost freedom of expression," that PWAP should "check up very carefully on the subject matter of each project. . . . Any artist who paints a nude for the Public Works of Art Project should have his head examined." The WPA Art Project produced mostly works of the American Scene but gave its artists more freedom than the other government projects. The Federal Art Project, especially the New York City Graphics Section, allowed artists working on this project more room to

20 (Opposite)
Untitled Winter Scene
By Ceil Rosenberg, Public Works of Art Project, 1934
Oil on canvas
Franklin D. Roosevelt Library, National Archives and Records Administration (MO 69-62)

experiment with styles and composition. An example of this flexibility is Anthony Velonis's serigraph, **Half Ton Fish** (fig. 22). Velonis first sketched scenes of the New York waterfront while working for New York City Mayor Fiorella LaGuardia's Poster Project, a part of the CWA in 1934. By 1938, while he was working for the WPA, he developed his more abstract design from those sketches.

The lives of American heroes, some familiar and a few less well known, was another historical theme explored by New Deal painters. President Abraham Lincoln was the subject of several murals as were frontiersman Daniel Boone, poet Carl Sandburg, and the explorers Lewis and Clark. These individuals were usually identified with the growth of liberal democracy. The WPA painter Mitchell Siporin chose a more contemporary heroine, the humanitarian social reformer Jane Addams, as his subject. In Siporin's painting, Addams is shown in the midst of the poor and dispossessed, to whom she dedicated much of her life at the Hull Street Settlement House in Chicago (fig. 36). Her support of labor is indicated by a worker and farmer shaking hands. A soldier breaking a sword signifies her leadership as the head of the Women's Peace Party and notes her achievement as the first American female Nobel Peace Prize winner.

The WPA's Theatre, Writers', and Dance Projects shared this interest in American historical biography. The FTP, for example, staged several different plays based on the life of Lincoln, and the best of these offered up a man largely unknown to 1930s theatergoers. Both **Prologue to Glory** by E. P. Conkle (fig.37) and **The Lonely Man** by Howard Koch humanized this American icon by focusing on Lincoln's early life, especially his romance with Ann Rutledge. **Prologue to Glory** was particularly popular, running 11 months in

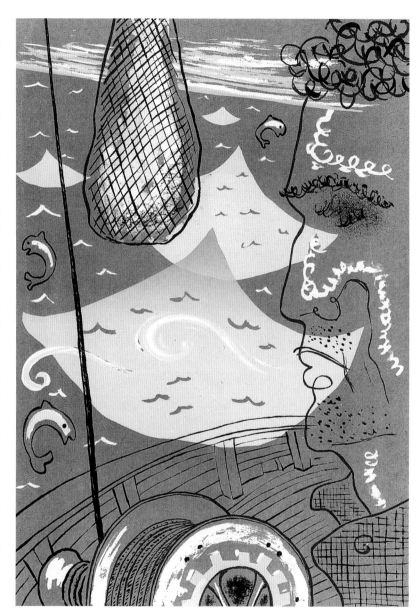

22
HALF TON FISH
By Anthony Velonis, New York City Federal Art Project,
WPA, 1938
Serigraph
National Archives, Records of the Office
of War Information (208-EX-206-56)

23

INDIAN VILLAGE

By Julius Twohy, Washington Federal
Art Project, WPA, ca. 1935–39
Lithograph
Franklin D. Roosevelt Library, National
Archives and Records Administration
(MO 56-327)

New York City. It was successfully staged in Los Angeles, San Francisco, New Orleans, Cincinnati, and Portland, Oregon. The play presents Lincoln as a common man whose early experiences, especially the tragedy of his love's death, provided a basis for greatness. Publicity for the New York City production received a boost when the great-grandniece of Ann Rutledge was cast as Lincoln's love interest.

American historical dramas could occasionally make more radical statements. The FTP drama **Battle Hymn** (figs. 32, 33) described the transformation of John Brown from pacifist to violent zealot and abolitionist martyr. Left-wing playwrights Michael Gold and Michael Blankfort sought and drew parallels for those seeking fundamental social change in 1930s America. They believed their research into the American past had uncovered "our own tradition of radicalism in this country." In a more traditional interpretation, as part of its Festival of American Dance, the dance program of the FTP produced **American Exodus** (figs. 34, 35), a modern

ballet celebrating the 19th-century westward migration of the American pioneer. It was, according to its choreographer, "a dance impression of a pioneer seeking a new land, its cultivation, the building of new homes, the harvest, the burden and nostalgia of women, love, and finally the joyous festival celebrating a full existence."

Of the hundreds of publications produced by the Federal Writers' Project, many dealt with American history and culture in new ways (fig. 25). The American Guide, for example, paid close attention to what one critic called "the humorous, the creepy, the eccentric side of the American character." Guidebooks described not only mainstream political and economic history but also local legends, landmarks, and lore. Designed to be lively, popular accounts, Writers' Project publications used oral histories and folktales to brighten their narratives and described a diversity of ethnic and other traditions. The New York City Writers' Project, for instance, produced both English and Italian versions of **The Italians of New York**. James Ladd Delkin of the Northern California Project wrote **Festivals in San Francisco**, a beautifully illustrated guide to the many ethnic celebrations in the city organized by month (fig. 27). The Chicago Writers' Project offered up **Baseball in Old Chicago**, a nostalgic look at the origins of the Great American Pastime in the Windy City that sought to "recreate for the fan of today the half forgotten, almost legendary exploits of diamond heroes who wore handlebar mustaches and caught barehanded behind the bat" (fig. 26).

The art projects also embraced a diversity of ethnic traditions. Because WPA Director Harry Hopkins insisted that the projects be open to all, marginalized groups now had employment opportunities where few had existed before. The Art Project, for instance,

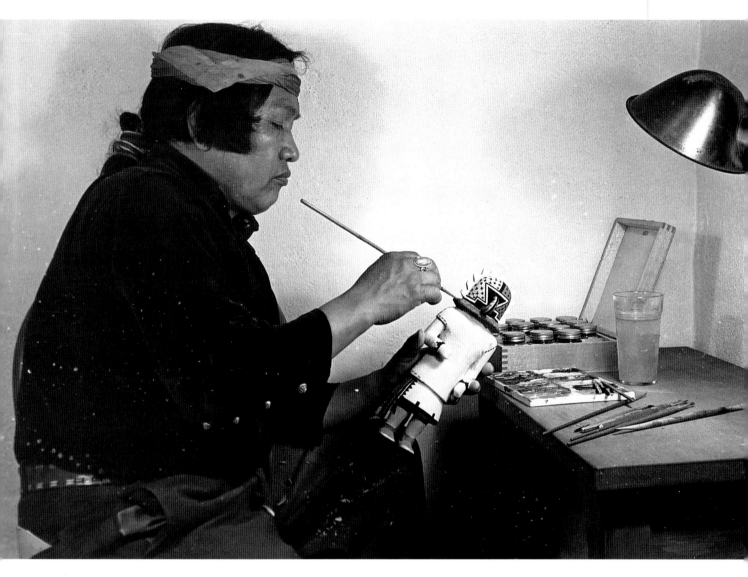

employed Native American artists, such as Washington State's Julius Twohy (fig. 23), in large numbers, and several post office murals were done by Indian artists or used Native American themes. In 1935 the Interior Department created the Indian Arts and Crafts Board, which promoted the development of markets for Native American arts and crafts through craft cooperatives and set standards for the art that would be sold in them (fig. 24).

In the case of African Americans, the arts projects rarely challenged the rigid racial seg-regation of 1930s America, but they did employ African-American artists and fostered a new interest in black history and culture. If some white artists continued to use stereo-typical images of African Americans, many other works demonstrated a new sensitivity and understanding of black culture. This was especially true of the Federal Theatre Project, which established several "Negro Units." The FTP production of Shakespeare's **Macbeth** set the tragedy in 19th-century Haiti (fig. 39). Two other plays, **Black Empire** and **Haiti**, explored the history of Haiti's successful rebel-

24
Hopi artist painting doll, ca. 1941–42
By Dorothy F. Whiting
National Archives, Records of the Indian Arts
and Crafts Board (435-CAT-3-6)

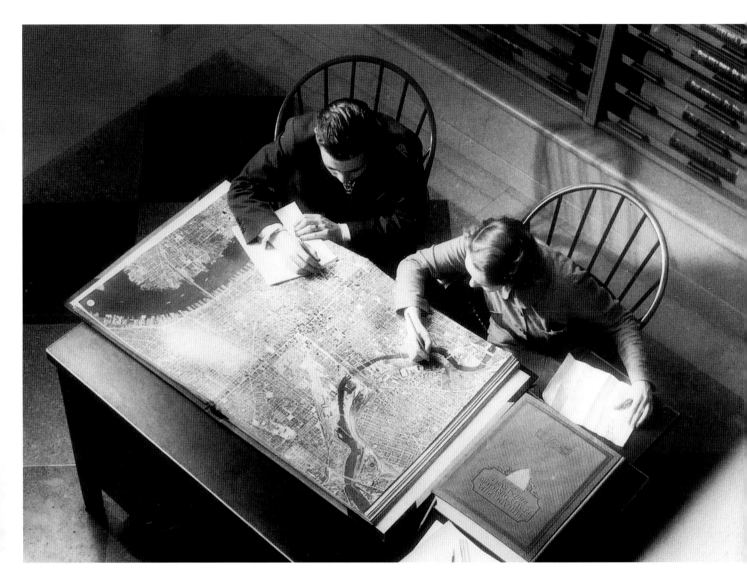

25

Staff of the Pennsylvania Federal Writers' Project using aerial maps to research the history and geography of central Philadelphia

By an unknown photographer, January 1936
National Archives, Records of the Work
Projects Administration (69-N-280)

lion against the French and sympathetically raised issues of black political power. Plays such as **In Abraham's Bosom**, set in a southern turpentine camp, and **Big White Fog** increased the nation's awareness of ˚racial discrimination, segregation, and abuse.

Another FTP show, Hall Johnson's **Run, Little Chillun**, was produced by the Negro Unit of the Los Angeles project and directed by Clarence Muse (figs. 40, 41). The play describes the tensions between a pagan folk religion and traditional black Christianity. Its main character, Jim, a preacher's son, is forced

to choose between his love for his wife, the traditionally pious Ella, and Sulamai, the seductive representative of paganism. Described as a "Negro folk drama with music," the Los Angeles production featured a large all-black cast and used African-American folklore and

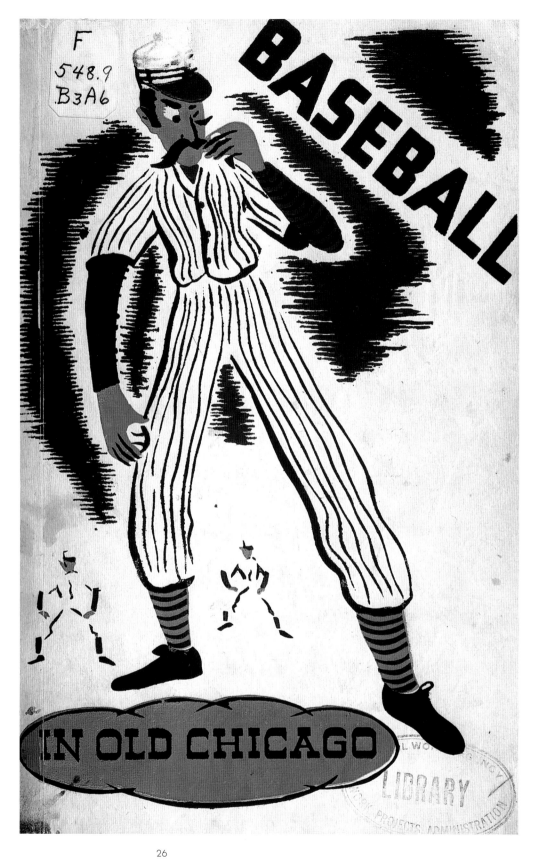

26
BASEBALL IN OLD CHICAGO
Compiled by the Illinois Writers' Project, WPA
Published by A. C. McClurg & Company, 1939
National Archives, Records of the Work Projects Administration

music to heighten the contrast between the two faiths depicted. The Los Angeles prodution was so popular that tickets for performances usually costing 55 cents were sometimes scalped for $4.

Several mural and writing projects also explored black history themes. Muralist James Michael Newell found the inspiration for his Dolgeville, New York, Post Office mural in stories of runaway slaves who had hidden in a cave at nearby Brockett Farm (fig. 38). The Washington, DC, Recorder of Deeds Office was decorated with seven murals by various artists, all of whom took as their theme the contributions of blacks to American history. Included were murals depicting Benjamin Banneker, Frederick Douglass, and Crispus Attucks.

One Writers' Project employee, Richard Wright (fig. 42), worked for both the Illinois and New York City projects. In Illinois Wright conducted ethnological research into Chicago's "black belt." After transferring to New York City in 1937, he became Editor for Negro Affairs and wrote the sections on African Americans for the New York City guide and on Harlem for the WPA publication **New York Panorama.** In "The Ethics of Living Jim Crow," Wright drew on his experience growing up as a black man under legalized segregation in the American South. His searing indictment of southern society exposed the violence, humiliation, and fear that millions of black Americans experienced. The essay first appeared in **American Stuff,** a volume devoted to the off-duty writings of WPA workers. Later it served as the opening of Wright's **Uncle Tom's Children.** In 1939 Wright left the project after receiving a Guggenheim Fellowship that allowed him to complete his novel **Native Son.**

It was perhaps the New Deal photographers who most skillfully recorded the American scene. They are most well known for capturing the hard times and poverty of the Depression, but most of their images concentrated on more benign and commonplace aspects of American life, including views of newsstands and streets, bus stations and roadside rests, churches and movie houses. These images were not as politically charged as some of the more strident ones from the 1930s. Instead they moved beyond simply celebrating, or criticizing, contemporary life. The best of these photographs are visual documents that subtly but skillfully explore the complex changes in 20th-century America.

Several New Deal photographs serve as good examples of this achievement. John Vachon's FSA photo of a newsstand in Omaha, Nebraska, is part of his larger portfolio made during his first solo assignment with the FSA in 1938 (fig. 31). The image is a straightforward—a close-up view of the titles available at one downtown newsstand. One is struck by the large variety of reading material handy to Omaha readers. A few of the titles displayed are serious photojournalism (**Time, Life,** and **Look**) or magazines on hobbies (**Popular Photography**). Most offer more sensationalistic fare about the lives of movie stars (**Screenland, Silver Screen**), romance and scandal (**True Story, Romantic Range**), crime (**Ten Stories of Gangs**), or westerns (**Lariet, Cowboy Short Stories**). Today we take such variety for granted, but the number of choices that faced a consumer in 1938 and the growth and popularity of tabloid journalism in the American heartland is impressive. While Vachon's image is straightforward, it is far from simplistic; it raises broad questions about popular culture, consumer choices, and the influence of the media in 1930s America.

Sol Libsohn took his photograph of a New York City diner as part of a WPA project

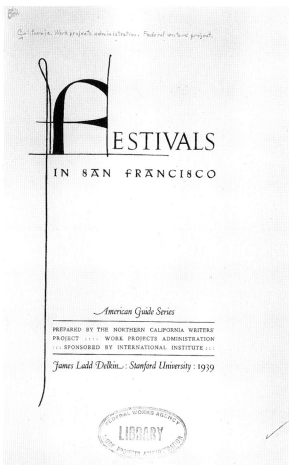

ESTIVALS
IN SAN FRANCISCO

American Guide Series

PREPARED BY THE NORTHERN CALIFORNIA WRITERS'
PROJECT :::: WORK PROJECTS ADMINISTRATION
::: SPONSORED BY INTERNATIONAL INSTITUTE :::

James Ladd Delkin : *Stanford University* : 1939

entitled "Food for New York City" (fig. 29). In it, individuals, mostly oblivious to the camera, cross a city street in front of the diner, which serves as the focal point of the photograph. While the image was shot as part of a photographic series designed to show how the city's food got from wharf to market and finally to a consumer's plate, Libshon's photograph can also be read as a document that is about the process of urban change. The small (family-owned?) business is dwarfed not only by the skyscrapers of New York but by the advertising signs that surround it. The picture gives a sense that the diner is about to be either overwhelmed by urban change or at least bypassed by it.

In contrast to Vachon's and Libsohn's urban images are the photographs taken by Dorothea Lange and Russell Lee (figs. 28, 30). These are photographs of rural America. On one level they seem to be images that simply catch slices of daily life. As such they fulfill Russell Lee's explanation of the photography projects: "to take pictures of its land and its people. The idea is to show New York to Texans and Texas to New York." But here, too, social change is a theme just below the surface. The cars around E. L. Bowman's grocery and filling station in Dawson County, Texas, are examples of an increasingly mobile population. The run-down church in a "shacktown" is located in a farmworkers camp in southern California. The workers who live there are mainly migrants from the dust

27
FESTIVALS IN SAN FRANCISCO
By James Ladd Delkin, Northern California Writers' Project, WPA
Art by Pauline Vinson, Northern California Art Project, WPA
Published by the Grabhorn Press, 1939
National Archives, Records of the Work Projects Administration

28

"Church in shacktown community. It is used
by different sects, including Pentecostal.
The curtains are made of flour sacks. . . .
Near Modesto, Stanislaus County California,
May 10, 1940"

By Dorothea Lange, Bureau of Agricultural Economics
National Archives, Records of the Bureau of Agricultural
Economics (83-G-41382)

bowls of the Great Plains. They have trans-
planted not only their families and labor to
new surroundings but also their religion.

The New Deal photographers' choices in
subject matter were intentional. The Reset-
tlement Administration and Farm Security
Administration, for example, gave their pho-
tographers "suggestions" about the content of
images the agency thought were most inter-
esting. One set of these came out of a 1936
conversation between FSA photography
director Roy Stryker and sociologist Robert
Lynd, co-author of the pathbreaking commu-
nity study **Middletown**. The resulting memo-
randum to all FSA photographers identified
the broad subject for FSA documentary work
as "American Background." Photographers
were to record a variety of commonplace
activities such as "Home in the evening," "Lis-
tening to the radio," "Visiting and talking,"
and "Men loafing and talking." The best loca-
tions to document such photographs were
churches, pool halls, lodges, saloons, street
corners, and homes. Other federal agencies
often gave their photographers similar guid-
ance.

It is not surprising that so many New Deal
artists chose to celebrate and probe the
American past, its land, and people in so
many ways. These themes fit nicely into what
New Deal arts administrators saw as under-
standable and accessible art that could be
understood and enjoyed in arts centers, pub-
lic buildings, and post offices around the
country. While there are a few examples of
American history being used to promote
reform or even radicalism, for the most part
New Deal art offered clear examples of com-
munity and spotlighted inspirational heroes
for a country in the midst of crisis and change.
These American scenes promoted a sense of
stability and national identity in a chaotic,
challenging time.

29
Photograph from the "Food for New York City" series
By Sol Libsohn, New York City Federal Art Project, WPA, 1939
National Archives, Records of the Work Projects Administration
(69-ANP-8-P3032-85)

30
"Grocery store and filling station in the
High Plains. Dawson County Texas,
March 1940"
By Russell Lee, Farm Security Administration
Prints and Photographs Division, Library of
Congress (LC-USF 34-35806-D)

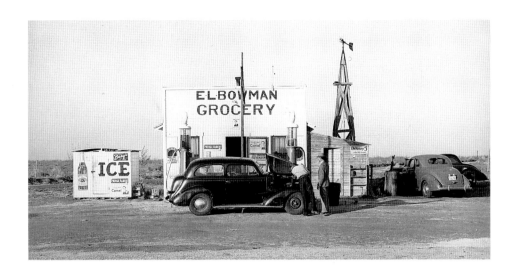

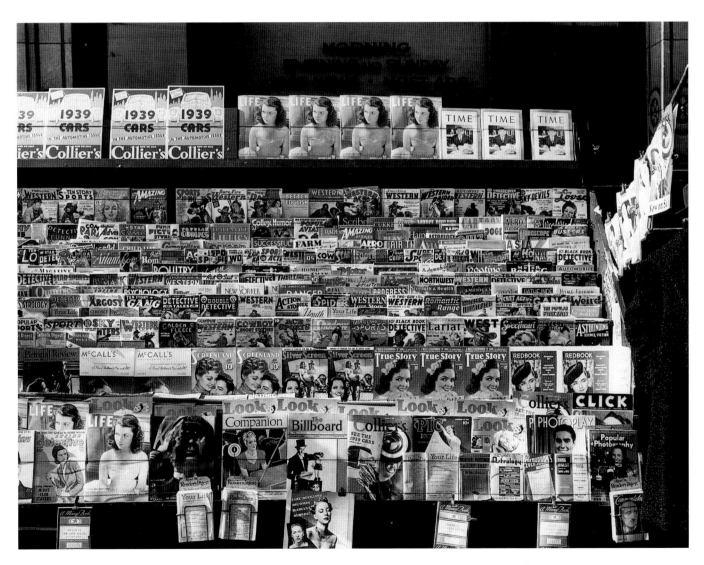

31
"Newsstand, Omaha, Nebraska, November 1938"
By John Vachon, Farm Security Administration
Prints and Photographs Division, Library of Congress
(LC 8939-D)

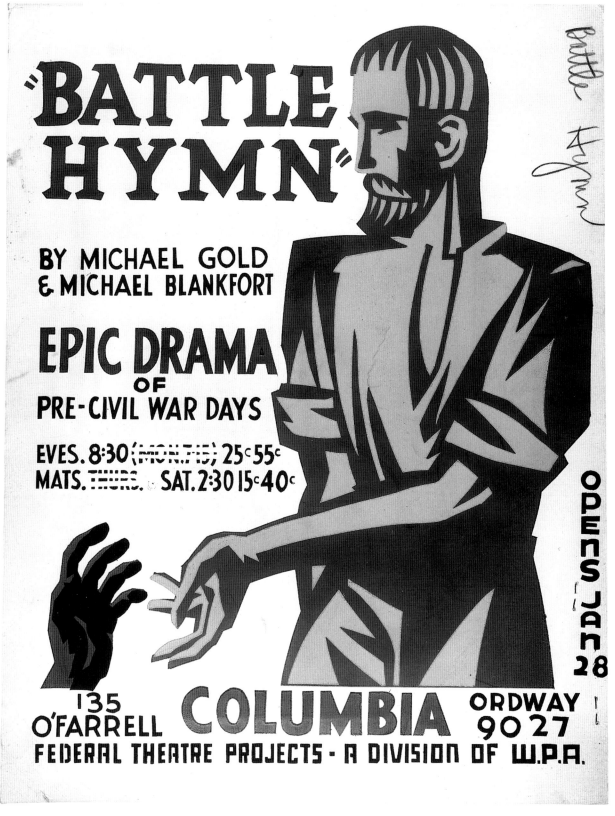

32
Poster for San Francisco, California, production of BATTLE HYMN
By an unknown artist, Northern California Federal Theatre Project, 1937
Silkscreen
National Archives, Records of the Work Projects Administration
(69-TP-32)

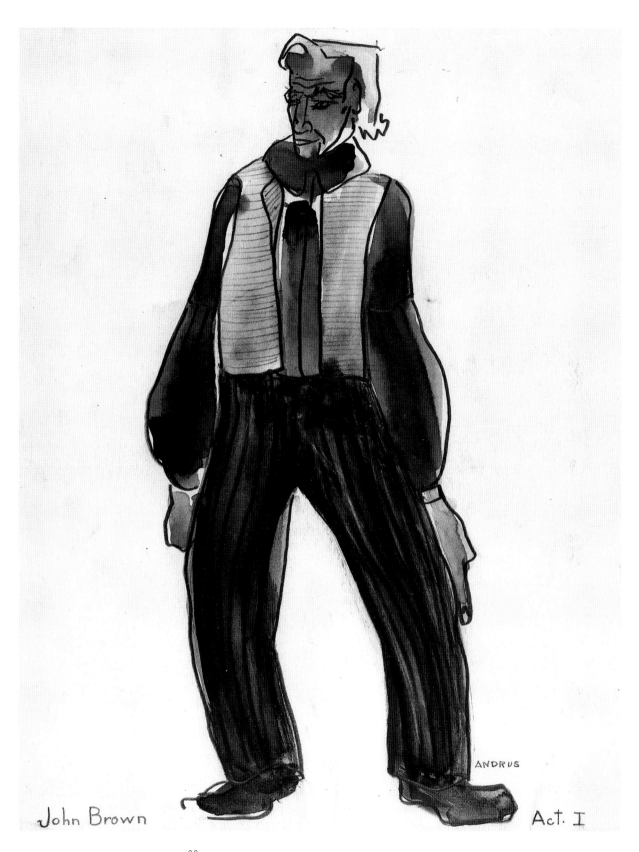

John Brown

Act. I

ANDRUS

33
"John Brown" costume design for Battle Hymn
By Zoray Andrus, Northern California Theatre Project, WPA, 1937
Watercolor over pencil on paper
National Archives, Records of the Work Projects Administration
(69-TSR-100)

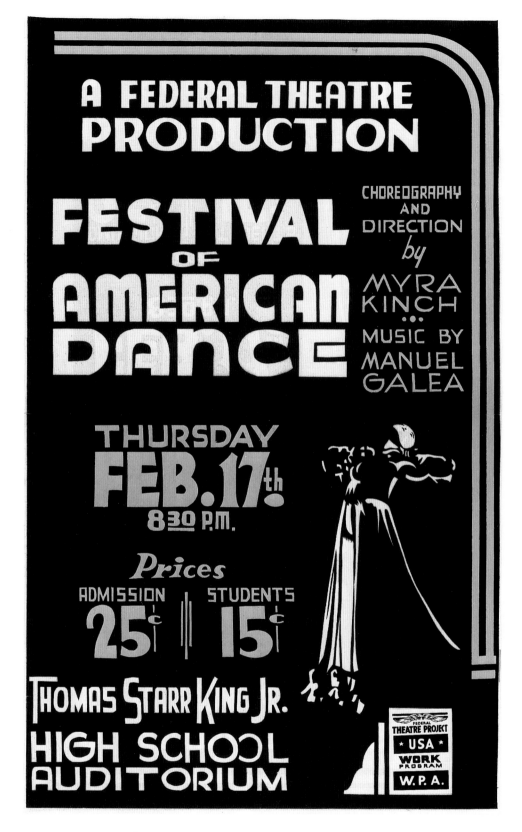

34
Poster for FESTIVAL OF AMERICAN DANCE
By an unknown artist, Los Angeles Federal Theatre Project, WPA, 1937
Silkscreen
National Archives, Records of the Work Projects Administration
(69-TP-145)

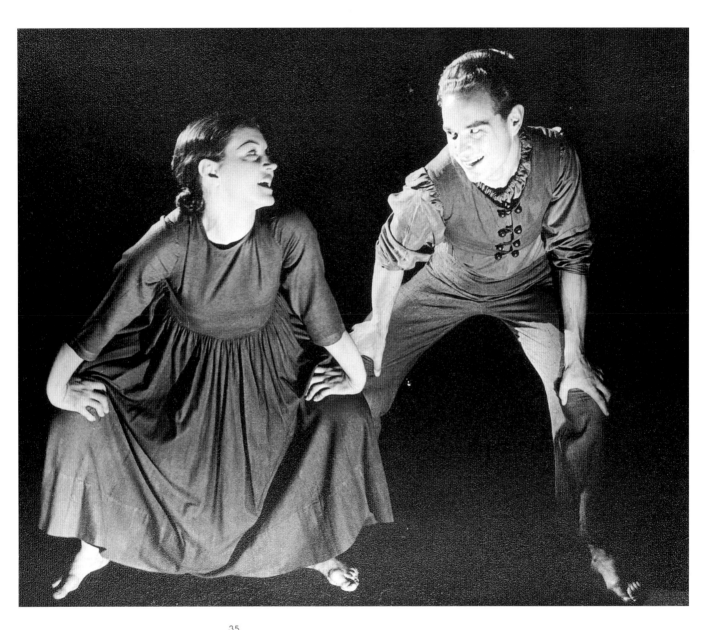

35
**Myra Kinch and Clay Dalton in the Los Angeles production
of AMERICAN EXODUS**
By an unknown photographer, 1937
National Archives, Records of the Work Projects Administration
(69-N-13159)

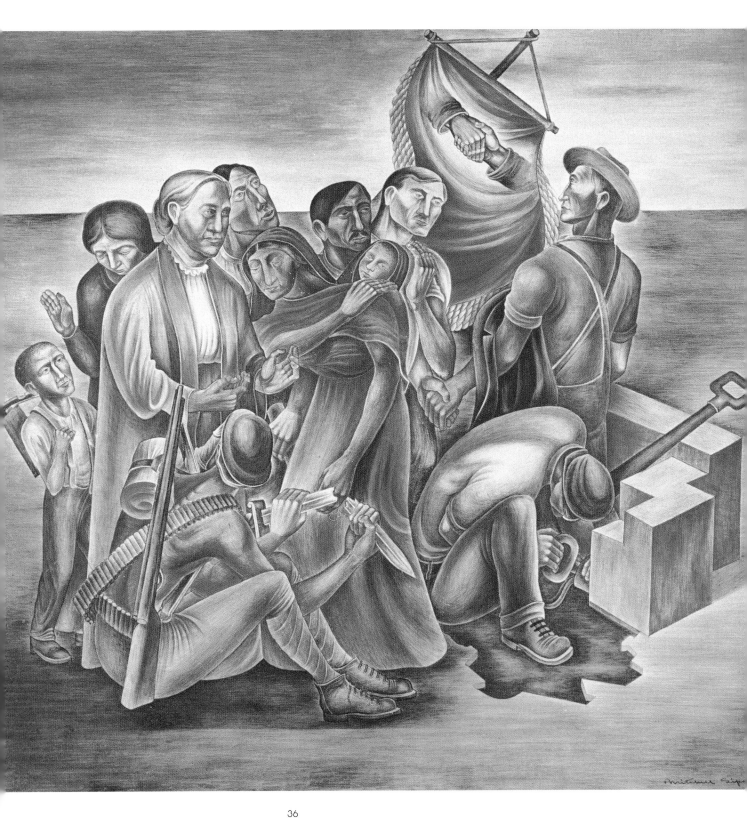

36
JANE ADDAMS MEMORIAL
By Mitchell Siporin, Illinois Federal Art Project, WPA, 1936
Tempera on masonite
Fine Arts Collection, General Services Administration (FA 216)

PRESENTS

PROLOGUE
TO
GLORY

The Romance of the
Young Lincoln
by
E.P. Conkle

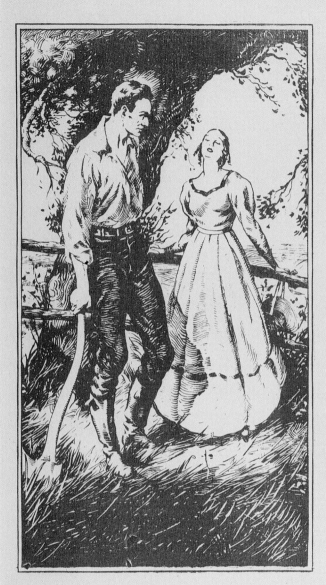

MAXINE ELLIOTT'S THEATRE
39th STREET, EAST OF BROADWAY
Prices: Orch. $1.10 and 83¢ 1st Balc. 55¢
2nd Balc. 25¢ · Matinees: 25¢, 40¢, 55¢ & 83¢
Evenings (Except Monday) at 8:40 Matinees, Saturday at 2:30

37
Handbill for PROLOGUE TO GLORY
Play by E. P. Conkle
Production by the New York City Federal Theatre Project, WPA, 1937
National Archives, Records of the Work Projects Administration

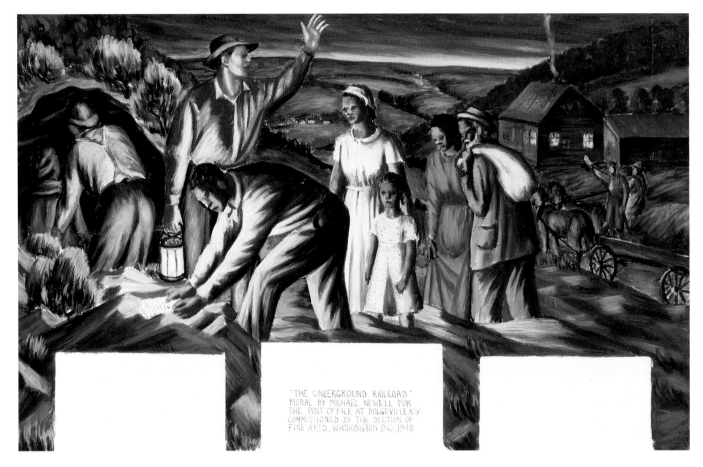

"THE UNDERGROUND RAILROAD"
MURAL BY MICHAEL NEWELL FOR
THE POST OFFICE AT DOLGEVILLE,N.Y.
COMMISSIONED BY THE SECTION OF
FINE ARTS, WASHINGTON,D.C.,1940

38

Study for UNDERGROUND RAILROAD

By James Michael Newell, Treasury Section of Fine Arts, 1940

Oil on paperboard

National Museum of American Art, Smithsonian Institution,

transfer from the Internal Revenue Service through General

Services Administration (1962.8.97)

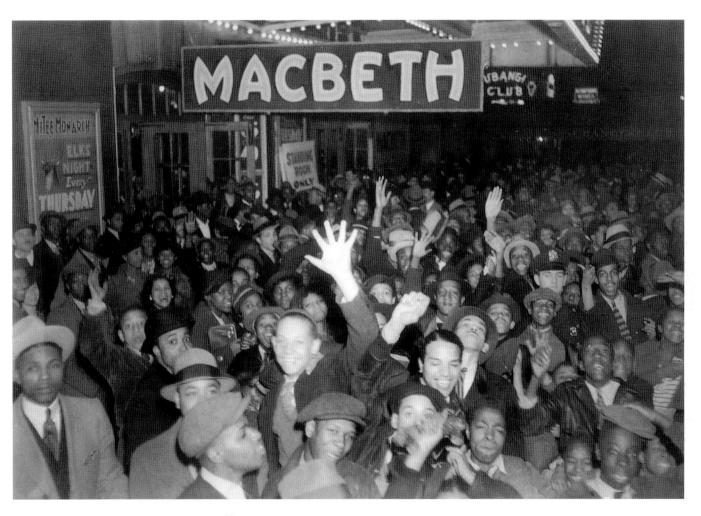

39

MACBETH—Opening night scene outside Lafayette
Theatre, New York City

By an unknown photographer, April 14, 1936

National Archives, Records of the Work Projects Administration

(69-TS-NY-695-48)

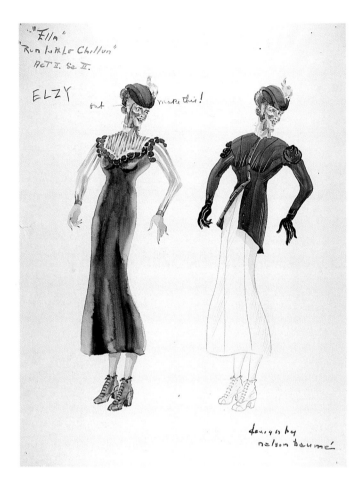

40
"Ella" costume design for RUN, LITTLE CHILLUN, Act II, Scene II
By Nelson Baumé, Los Angeles Federal Theatre Project, WPA, 1938
Watercolor and graphite over pencil on paper
National Archives, Records of the Work Projects Administration
(69-TSR-97)

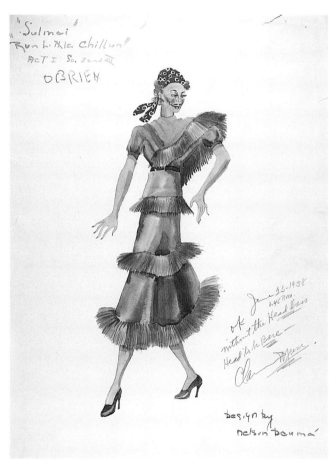

41
"Sulinai" [sic] costume design for RUN, LITTLE CHILLUN,
Act I, Scenes I and III
By Nelson Baumé, Los Angeles Federal Theatre Project, WPA, 1938
Watercolor over pencil on paper
National Archives, Records of the Work Projects Administration
(69-TSR-94)

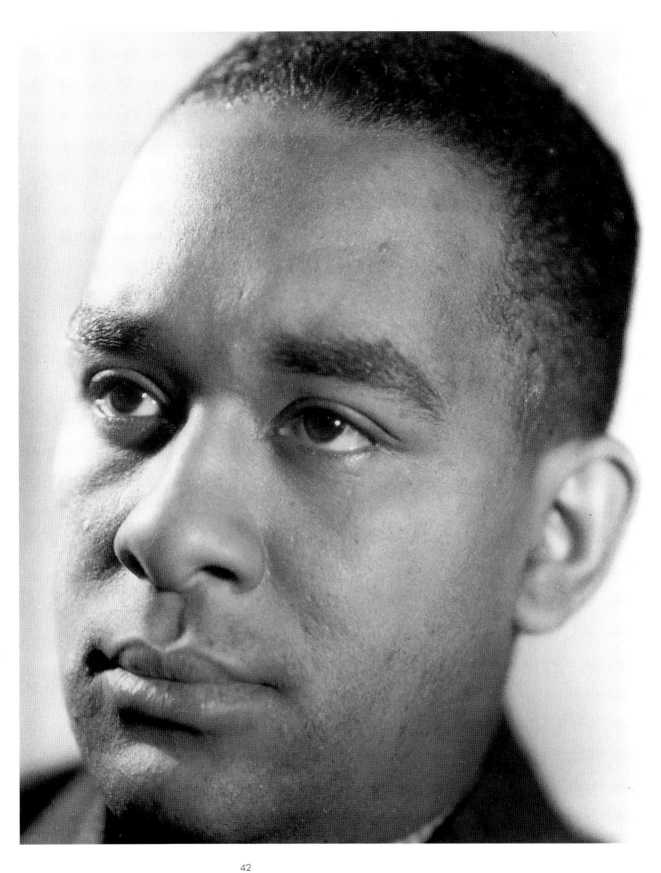

42
Richard Wright
By an unknown photographer, ca. 1940
National Archives, Records of the Work Projects Administration
(69-N-19585)

43
Michigan artist Alfred Castagne sketching WPA construction workers
By an unknown photographer, May 19, 1939
National Archives, Records of the Work Projects Administration
(69-AG-410)

C elebrating "the People"

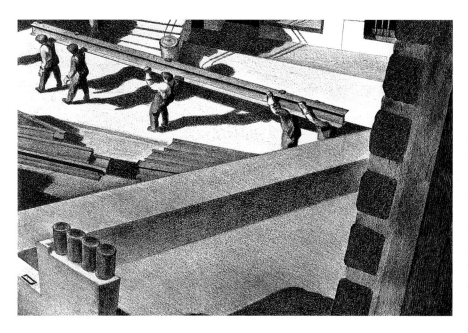

44
ROOF AND STREET
By Louis Lozowick, New York City Federal Art Project, WPA, 1938
Lithograph
Franklin D. Roosevelt Library, National Archives and Records Administration (MO 56-268)

ture to enhance stories that centered on the lives of ordinary people.

In depicting the course of daily life, New Deal visual artists memorialized routine events such as waiting for a train or workers going about their daily tasks. At first glance, such subjects may seem to be a celebration of the mundane, but behind these vignettes lay a belief that they represented the essence of modern American life as lived by most individuals. Artists considered it to be their responsibility to capture such core experiences. One New Deal muralist put it this way: "It is my belief that there is sufficient drama and dignity among our people and the daily routine of living so that a painter need not resort to melodramatic paraphernalia or specious 'profundity.'"

Louis Lozowick's lithograph **Roof and Street** is one of many paintings and prints that took the city as its setting and the lives of blue collar workers as its subject (fig. 44). The print shows an urban street from the perspective of a window in a nearby building. Five workers carry a heavy steel girder down the street past a stack of other girders. The window serves as a frame for the action below; the print's composition emphasizes the intersection of lines and angles made by the roof, window, sidewalk, steps of a townhouse,

The economic crisis of the 1930s focused the attention of Americans on the lives and struggles of ordinary folk. Not surprisingly, much New Deal art reflected this preoccupation with "the people." Government visual artists, writers, and playwrights concentrated many of their creative efforts on the patterns of everyday life, especially the world of work (fig. 43). A recurring theme was the strength and dignity of common men and women, even as they faced difficult circumstances. Writers and folklorists used the new technique of oral history interviewing to write work his-

> "*Always the heart and soul of our country will be the heart and soul of the common man.*"
>
> —Franklin Roosevelt, campaign address, Cleveland, Ohio, November 2, 1940

tories that were integrated into broader state and local histories. Painters, printmakers, photographers, and sculptors looked to the streets to depict daily routines and to find models. Federal Theatre Project plays used music, dialect, and images from popular cul-

walls, and girders. This print is not as overtly political as many of Lozowick's works, but the artist does imply the collective power and strength of the workers. One could argue that the viewpoint of the painting, the artist's apartment or studio, is possibly intended to

show solidarity with the working class.

The worker is also the topic of Ben Shahn's **The Riveter** (fig. 45). This study was one of two works submitted by Shahn as his winning entry for the competition to decorate the Bronx, New York, Central Postal Station. It takes up one of 13 panels on 4 walls of the station. The entire work, which is entitled **Resources of America**, celebrates the skills of a variety of American industrial and agricultural workers. Its theme is that human beings and their skills are as important to preserve as natural resources such as soil and water. Best known for his depictions of social issues, Shahn worked as a photographer for the Resettlement Administration and Farm Security Administration. Many of his FSA and Resettlement photographs served as studies and inspiration for his later paintings and graphic work.

Like Lozowick, Raphael Soyer's work concentrated on scenes from the everyday experience of urban living. For his inspiration, Soyer turned to the streets of New York City; for his models, he would sometimes hire the homeless. His work has a sad, sentimental quality that, in the words of one critic, highlighted "a series of episodes in the lives of simple, even drab human beings." **Working Girls Going Home** captures some of this feeling, picturing several anonymous women on a busy rush-hour street (fig. 46). The viewer is drawn to the women's tired faces, which are surprisingly similar to one another. Soyer shows them close up, but their faces reveal

45
The Riveter
By Ben Shahn, Treasury Section of Fine Arts, 1938
Tempera on paperboard
National Museum of American Art, Smithsonian
Institution, transfer from General Services Administration
(1974.28.371)

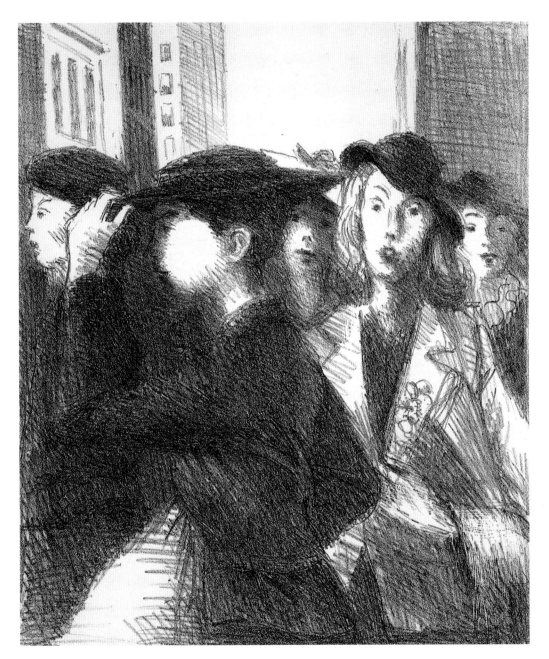

46
WORKING GIRLS GOING HOME
By Raphael Soyer, New York City Federal Art Project, WPA, 1937
Lithograph
Franklin D. Roosevelt Library, National Archives and Records Administration
(MO 56-323)

few details, and some are in shadow. This sense of anonymity and sameness is reinforced by Soyer's choice to place the women's covered heads all at the same height.

Jack Markow's **El Station, Sunday Morning** depicts another typical city scene (fig. 47). By the 1930s and 1940s, the "El"—short for elevated railway—was a common means of intra-urban transportation in large cities such as New York City, and several New Deal artists used "El stations" as their setting for prints, paintings, or photographs. Markow's lithograph captures the quiet solitude of an almost deserted Sunday morning rail platform at one of these stations, which appears to be situated in a working-class section of the city. He shared with Raphael Soyer an interest in the lives of nameless individuals. The lone figure waiting on the platform bench is almost featureless. His cap is pulled down and his collar turned up against the cold. His hands are thrust deep into his coat pockets. The question of whether the man is simply waiting for a train or has been on the bench all night is left to the viewer's imagination.

A more upbeat composition is Paul Clemens's **In the Dugout** (fig. 48). Clemens's subject for his oil painting is baseball. He freezes a typical scene, not in the game itself, but just off the field. A manager watches while a player waits for his turn at bat, and a fan asks another player for an autograph. The focus here is not on the action of the game but on baseball as a spectator sport, on the growing importance of leisure time, and on the public culture ritual of asking for a celebrity's autograph.

Another aspect of daily life that recurs in New Deal art is mail handling. Since so many murals were destined for post office lobbies, it is not surprising that processing, delivering,

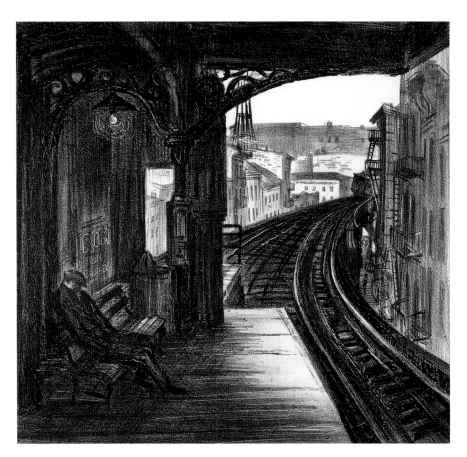

47
EL STATION, SUNDAY MORNING
By Jack Markow, New York City Federal Art Project, WPA, ca. 1935–39
Lithograph
Franklin D. Roosevelt Library, National Archives and Records Administration (MO 56-271)

and receiving mail were some of the most common subjects in Section murals. These most frequently depict advances in technology such as the development of air mail or major turning points in postal history like the pony express. In **Waiting for the Mail,** a mural for the Nappanee, Indiana, Post Office, Grant Wright Christian chose instead to paint a familiar yet private moment as a women waits anxiously for a letter (fig. 51). A critique by an advisory panel suggested adding the figure of a dog with an "eager expression" to relieve "the large area of fence [that] might prove monotonous." In the final mural, Christian also changed the dog's breed.

The patterns of everyday life were the subject of several other murals. Lucienne Bloch's **Cycle of a Woman's Life** was painted for the Women's House of Detention in New York City (figs. 49, 50). When Bloch arrived at the House of Detention and suggested her topic, she found resistance to her plan. The inmates and staff considered mural art too "highbrow" for a prison. The warden disagreed with Bloch's subject matter because

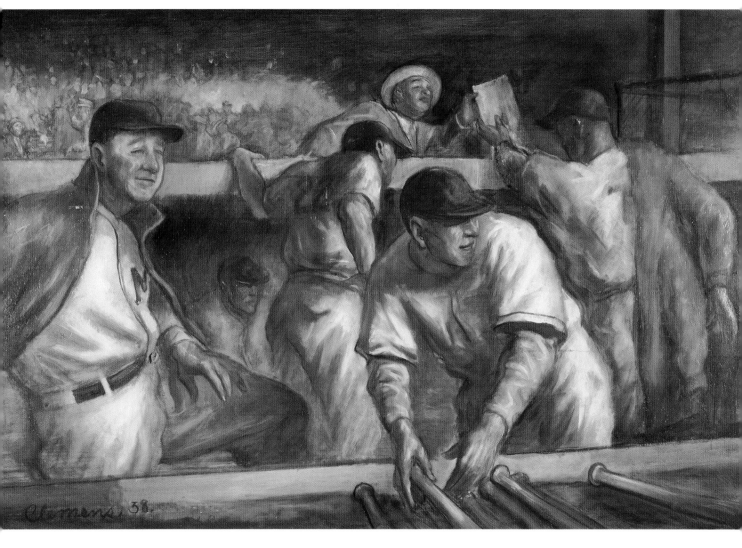

48
IN THE DUGOUT
By Paul Clemens, Wisconsin Federal Art Project,
WPA, 1938
Oil on masonite
Franklin D. Roosevelt Library, National Archives
and Records Administration (MO 56-330)

she felt depicting "ragged children" in the city might have too many "unpleasant associations" for the residents. Bloch eventually won over everyone with her composition. One panel, **Childhood,** depicted a New York City playground scene with several generations of women as the mural's central characters. The New York City skyline serves as a background, and both black and white children play happily together on swings, on a slide, and in the sand. Sadly, Bloch's fresco has been destroyed.

Portraiture and sculpture also reflected this renewed interest in people of ordinary

circumstances, and the New Deal projects afforded artists with this inclination the opportunity to study and record the faces of workers, the unemployed, and the poor. For example, in Depression America, many young people faced a bleak future with little hope of finding work, starting a family, or following their dreams. Joseph Vavak's somber double portrait **Character Study** captures a young couple's frustration and disillusionment (fig. 53). The man holds a newspaper open to the want ads and stares angrily. The woman gazes blankly into the distance. Another New Deal artist, Dox Thrash, an

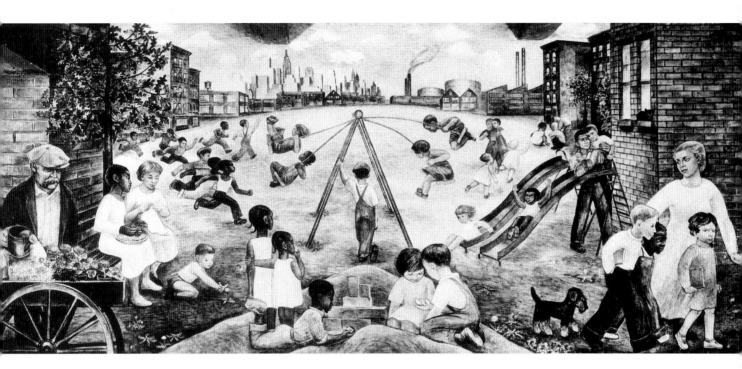

African-American printmaker, was one of many artists, black and white, who found subject material within the black community. Thrash's **Second Thought** shows a pensive young black man lost in his decision making (fig. 54). An artist with the Philadelphia FAP, Thrash, along with several fellow project employees, has been credited with the development of the carborundum print, which uses a siliconcarbide abrasive in the printmaking process.

Sculptor Donel Hord merged his interest in the lives of the poor with his preoccupation with Southwestern themes. His marble sculpture **Mexican Mother and Child** catches the poverty, but also the inherent dignity, of a Hispanic women as she walks, face turned to the viewer, with her child on her back (fig. 57). In addition to **Mexican Mother and Child**, Hord completed several large public works that highlighted the Hispanic influence in the American West. His **Aztec** can be seen on the campus of San Diego State University in California, and his fountain, **Guardian of Water**, sits outside the San Diego City Hall.

New Deal photographers deeply felt the importance of recording the lives of "anonymous people." FSA photographer Walker Evans described his work as finding "what is in . . . faces and in the windows and in the streets . . . what [people] are wearing and what they are riding in, and how they are gesturing." Other New Deal photographers followed Evans's maxim closely. Irving Rusinow's marvelous photograph of an elderly Hispanic man in El Cerrito, San Miguel County, New Mexico, not only captures the gentleman's great bearing, but it allows us to see the trappings of his life: the wood stove that dominates the photograph's foreground, the man's hat and cane, the religious paintings and icons on the wall, and his bed, dresser, and chest (fig. 58). Interestingly, the photograph's caption stresses his subject's social station, emphasizing that he was "descended from one of the oldest families in the village, and his house is also one of the oldest there."

49
CHILDHOOD panel in CYCLE OF A WOMAN'S LIFE
By Lucienne Bloch, New York City Federal Art Project, WPA, 1936
National Archives, Records of the Work Projects Administration (69-N-AG-98-672)

50 (Opposite)
"Lucienne Bloc[h] . . . is shown executing one of the processes in the making of a fresco painting. The mural entitled, 'Cycle of a Woman's Life' is in the House of Detention, New York City"
By an unknown photographer, 1936
National Archives, Records of the Work Projects Administration (69-N-13265)

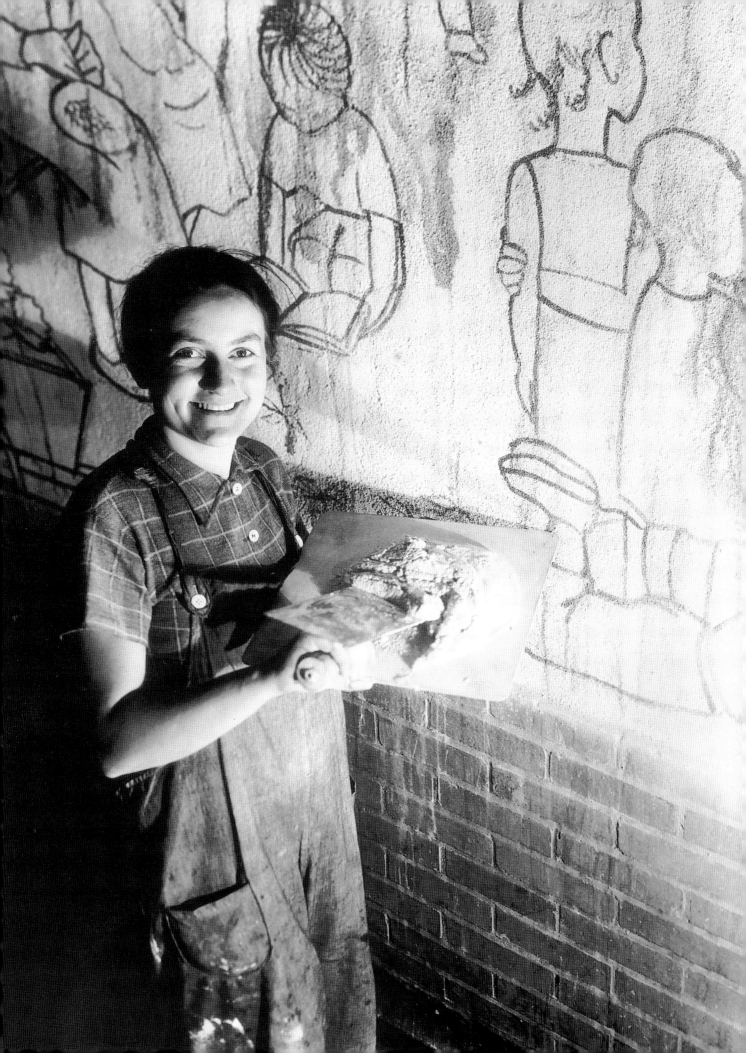

Two photographs by Dorothea Lange and another by George Ackerman pay similar attention to detail and faces (figs. 59–61). Lange's photographs, one of Japanese agricultural workers, taken for the Farm Security Administration, the other of farmers waiting for their relief checks, taken for the Bureau of Agricultural Economics, emphasize her subjects' expressions and clothing. We are drawn to the hats and clothing that protect mother and daughter from the California sun. In Lange's photograph of the relief recipients, it is the sunburned faces, the clothing, the jaunty postures, and the differing expressions of the two central figures that engage the viewer's attention. Ackerman, who worked for many years as the chief photographer of the Agriculture Department's Federal Extension Service, used his photography to describe "a better way of life for rural people." His work "specialized . . . in the everyday things." When he photographed an Iowa farm woman reading in her home, he intended the photograph to convey a sense of the progress made by the modern American farm family. The woman is alone but not isolated—she sits reading a newspaper with

the farm's telephone nearby. She has time for leisure pursuits—a fact made clear by her reading and by the houseplants in the window.

Federal Theatre productions often told stories of ordinary individuals caught up in forces beyond their control. Such creations, dramatists and directors believed, revealed a presence and strength of character that was missing from portraits of the rich and powerful. **Life and Death of an American** by George Sklar tells the story of Jerry Dorgan, the fictional first child born in the 20th century at 12 seconds after midnight, January 1, 1900 (figs. 55, 56). Dorgan represents an everyman whose hopes and dreams parallel recent American history. Born into a poor family, he leaves college when his father dies, learns to fly during World War I, and prospers during the boom years of the 1920s. He loses his job because of the Depression and is eventually killed in a labor strike.

Another FTP production, **Jericho,** is set in the rural South and in New York City's Harlem and tells the story of a black minister's son who is lured away from his family, church,

51
Waiting for the Mail
By Grant Wright Christian, Treasury Relief Art Project, 1937–38
Oil on canvas
National Museum of American Art, Smithsonian Institution, transfer from General Services Administration (1974.28.298)

52
"Tobacco workers rolling hogshead,
Richmond, Virginia"
By Robert H. McNeill, Virginia Federal Writers'
Project, WPA, 1938
From THE NEGRO IN VIRGINIA
Courtesy of Mr. Robert H. McNeill

and sweetheart by the promise of money and fame for boxing in the urban North. The title character ultimately faces the choice of gaining a fortune or betraying those he loves when he is asked to throw a fight. The play's use of dialect and African-American religious and folk music enhanced the contrast between urban and rural black life.

Interest in American folklore and music was growing even before the Great Depression and the New Deal, but the number of writers employed by the Writers' and Music Projects allowed folklorists and students of folk music to undertake large and comprehensive projects. Writers' Project workers interviewed members of ethnic groups and working people about their lives and work. They talked with former slaves and collected work and life histories of Jewish garment workers, Connecticut clock makers, Chicago steelworkers, and Arizona copper miners. They preserved Native American legends,

Spanish-American games, and the "tall tales" of Montana's copper camps. Likewise, Music Project and Resettlement Administration field workers drove across the country with their portable equipment, recording and transcribing work songs, folk ballads, spirituals, and other music from diverse ethnic traditions (figs. 64, 65). Project workers hoped these interviews and recordings would eventually lead to publications, but most remain unpublished. This raw material, however, has provided a rich resource for a variety of novelists, folklorists, and historians.

These Are Our Lives, a groundbreaking work of oral history, included the stories of black and white tenant farmers, sharecroppers, cotton mill workers, vagrants, and peddlers (fig. 63). But these sketches were not limited to work histories. The people interviewed discussed family life, education, politics, religion, medicine, and leisure time as well. Another WPA publication, **The Negro in**

Virginia, incorporated interviews with former slaves and other WPA interviews into a broader history of African Americans in Virginia. The volume dealt forthrightly with issues such as slave revolts and the inhumane treatment of slaves at the hands of their masters as well as with contemporary economic issues. Researched and written by an all-black staff led by editor Roscoe Lewis of Hampton Institute, the volume included images by the noted photographer Robert McNeill (fig. 52). It was one of only two separate histories of African Americans published by the Writers' Project; several state guides, however, contained chapters on black history.

Dance productions, too, used folk music and were inspired by stories of everyday life. The ballet **Frankie and Johnny** was inspired by the blues song of the same name and told the story of love, betrayal, and murder set in a run-down bar (fig. 62). **American Pattern** portrayed the difficult choices faced by a modern woman. **How Long Brethren** dramatized the African-American struggle for justice and set its choreography to black songs of protest. **Young Tramps** described the plight young people faced when they were forced onto the road by the Depression. Subjects like these were chosen for the Federal Dance repertoire because of their appeal to audiences who, although unfamiliar with classical ballet, might take a chance on an evening of dance if the program's themes related to the issues of contemporary life.

Several themes resonate through these 1930s depictions of the common man and woman. The commonplace, whether it be waiting for the mail, working as a riveter, looking for a job, or returning home from work, is viewed as anything but common. Everyday experiences, especially work, are seen in an almost heroic light, and the situa-

53
CHARACTER STUDY
By Joseph Vavak, Illinois Federal Art Project, WPA, ca. 1935–39
Lithograph
Franklin D. Roosevelt Library, National Archives and Records Administration (MO 56-293)

54
SECOND THOUGHT
By Dox Thrash, Pennsylvania Federal Art Project, WPA, 1939
Carborundum, mezzotint, and aquatint
Franklin D. Roosevelt Library, National Archives and Records Administration (MO 56-290)

tions and choices faced by ordinary people are momentous. Simply living and working during the Depression took courage, skill, and perseverance. For New Deal artists, recording the lives of "anonymous people" on canvas, on the stage, or through interviews took on special importance. The reason was not just that the particulars of life—food, work, clothing, and housing—were often in short supply. Perhaps it was because these activities were seen as vital to industry, family, and society.

LIFE AND DEATH OF AN AMERICAN
a new play
by
GEORGE SKLAR

Evenings (exc. Mon.) at 8:40

Evenings 25¢ to $1.10

Saturday matinee at 2:40

Matinees 25¢ to 83¢

For theatre parties at special rates, call GRamercy 7-7800, ext. 56

MAXINE ELLIOTT'S THEATRE
39th Street, East of Broadway

Printed by Publications Division, National Service Bureau

55
Handbill for LIFE AND DEATH OF AN AMERICAN
Play by George Sklar
Production by the New York City Federal Theatre Project, WPA, 1939
Printed ink on paper
National Archives, Records of the Work Projects Administration

56
Arthur Kennedy and Eleanor Scherr in LIFE AND DEATH OF AN AMERICAN
By an unknown photographer, New York City Federal Theatre Project, 1939
National Archives, Records of the Work Projects Administration
(69-TS-NY-689-4)

57

MEXICAN MOTHER AND CHILD

By Donel Hord, California Federal Art Project, WPA, 1938
Tennessee Marble
Franklin D. Roosevelt Library, National Archives and Records Administration
(41-5-45)

58

"This man is descended from one of the oldest families in
the village, and his house is also one of the oldest there.
El Cerrito, San Miguel County, New Mexico."

By Irving Rusinow, Bureau of Agricultural Economics, April 10–16, 1941
National Archives, Records of the Bureau of Agricultural Economics
(83-G-37828)

59
"Japanese mother and daughter, agricultural workers.
Near Guadalupe, California, March 1937"
By Dorothea Lange, Farm Security Administration
Prints and Photographs Division, Library of Congress
(USF 34 16129-c)

60
"Line up for state relief payday. April 13, 1940."
By Dorothea Lange, Bureau of Agricultural Economics
National Archives, Records of the Bureau of Agricultural Economics
(83-G-41411)

61 (Opposite)
"Farm Woman sitting before her large
window, Jones County, Iowa,"
By George W. Ackerman, Department of
Agriculture, September 8, 1936
National Archives, Records of the Office of the
Secretary of Agriculture (16-G-168-S-22210c)

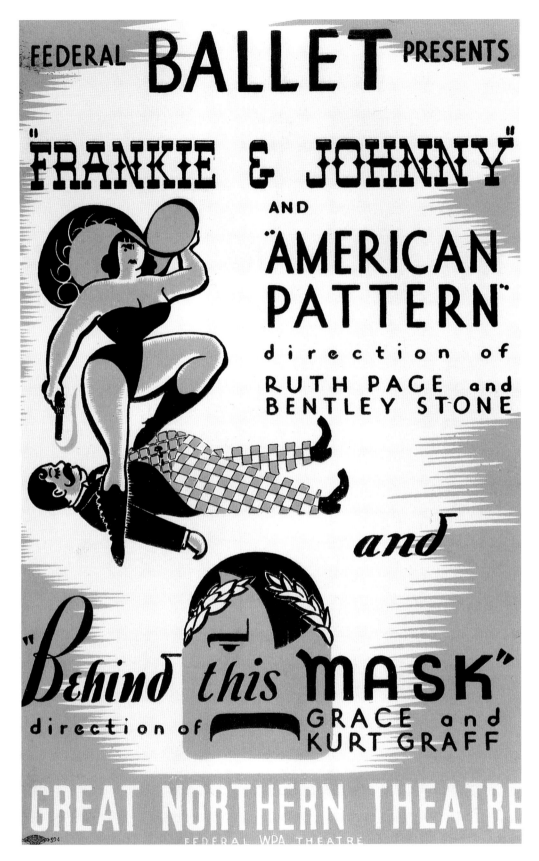

62
"Federal Ballet Presents"
Illinois Federal Theater Project, 1938
National Archives, Records of the Work Projects Administration

These
Are Our Lives

AS TOLD BY THE PEOPLE AND WRITTEN BY
MEMBERS OF THE FEDERAL WRITERS' PROJECT
OF THE WORKS PROGRESS ADMINISTRATION IN
NORTH CAROLINA, TENNESSEE, AND GEORGIA

CHAPEL HILL 1939

THE UNIVERSITY OF NORTH CAROLINA PRESS

63
THESE ARE OUR LIVES
North Carolina, Tennessee, and Georgia Federal Writers' Project
Published by University of North Carolina Press, 1939
National Archives, Records of the Work Projects Administration

64
"Walkin' Boss"

As sung by Tricky Salmon, Johnny Smith, and Alexander Williams
Recorded by Herbert Halpert, Joint Committee on Folk Art, WPA, ca. 1940
Transcribed by Frank Harmon, Joint Committee on Folk Art, WPA, ca. 1940
National Archives, Records of the Work Projects Administration

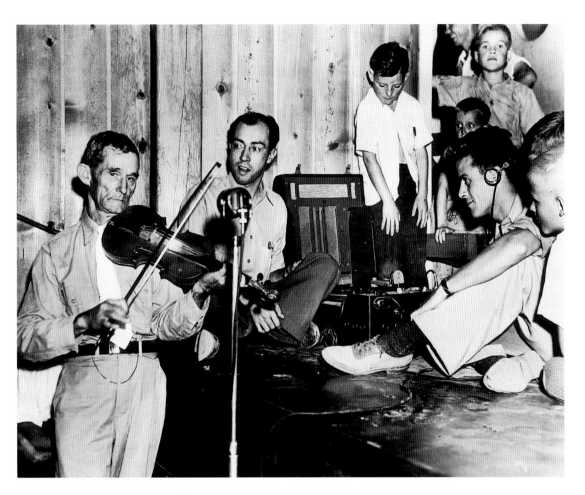

65
**Robert Sonkin and Charles Todd record a fiddler
at a Farm Security Camp in California**
By Robert Hemmig, 1940–41
American Folklife Center, Library of Congress

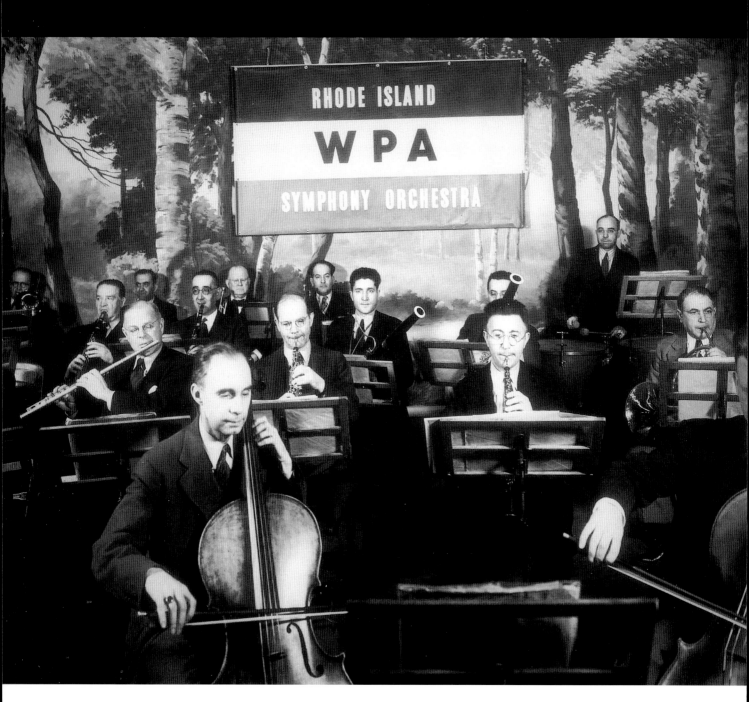

66

The Rhode Island WPA Music Project Orchestra

By an unknown photographer, undated

National Archives, Records of the Work Projects Administration

(69-MP-17-1)

*W*ork Pays America

Most New Deal artists were grateful to President Roosevelt for creating the arts projects, and they enthusiastically supported the New Deal's liberal agenda. Not surprisingly, their art reflected this point of view. It celebrated the social and economic progress made under President Roosevelt and promoted his programs. It emphasized what America had gained through the New Deal and contrasted these advances with what they saw as the misery and poverty of earlier years. While the government occasionally

and world fairs as public relations tools. Throughout his tenure in office, President Roosevelt made extensive and masterly use of the radio. In his "fireside chats," as his radio addresses to the American people came to be called, FDR skillfully conveyed a sense of intimacy, immediacy, and urgency to his audience.

Works produced by the arts projects could be an extension of these kinds of public relations techniques. The most obvious example was the WPA logo and name. The

> "We were all very ardent New Dealers and when we found [New Deal policies] reflected in the art programs we were even more enthusiastic."
>
> —Edward Biberman, New Deal artist

commissioned such works of art, most were offered up freely by artists who genuinely admired the New Deal programs and who saw themselves as the champions of not just the government but of the citizens who needed the assistance it brought.

Of course, such artistic efforts were especially popular with politicians and bureaucrats seeking to publicize the New Deal's achievements. The New Dealers were not shy about boosting their policies and programs through a variety of media. During the early months of the New Deal, they promoted FDR's National Recovery Administration (NRA), an early effort to stabilize prices and wages, through radio addresses, public rallies and parades, songs, and the familiar "Blue Eagle" NRA logo. The Blue Eagle, with its "We Do Our Part" slogan, appeared everywhere. It was on placards, banners, and posters; in store windows, in factories, in mines; and on the masthead of newspapers. New Dealers also used exhibits in federal buildings, expositions,

red, white, and blue Works Progress Administration logo was one of the most familiar symbols of the New Deal. It appeared on WPA artwork, on Federal Theatre playbills, and at music and dance performances (figs. 66, 67). Its initials were sometimes said to stand for "Work Pays America."

Although the figure of President Roosevelt was another obvious subject for artists seeking to show their support for the New Deal, FDR's image only occasionally appears in New Deal art. This paucity of Roosevelt images is especially noticeable when compared to the cults of personality fostered by totalitarian governments of the same time such as Nazi Germany or the Soviet Union. One artist who did use the President as his subject was Olin Dows. In one panel of the post office mural for FDR's home town of Hyde Park, New York, Dows shows the President discussing plans for Roosevelt High School with the members of the local school board (fig. 68). Like many of the individuals

who headed the arts programs, Dows was an artist turned administrator. He served as an official with the Treasury Department's Section of Painting and Sculpture, and he headed the Treasury Relief Art Project. President Roosevelt took special interest in Dows's mural, suggesting themes and criticizing early sketches.

Artists focused most of their attention on the social benefits of the government programs FDR inaugurated, especially those that assisted the unemployed and impoverished. They had plenty of subject material with which to work. Under the New Deal, the federal government grew at an unprecedented rate, and political power shifted away from the states to Washington, DC. There was increased federal regulation of business and the economy. New Dealers created agencies that reformed the banking system, built dams to promote hydroelectric power and prevent floods, brought collective bargaining to the workplace, and, of course, employed millions on public works projects. In addition to the WPA, the list of new agencies was a long one that included the Agricultural Adjustment Agency (AAA), the Civilian Conservation Corps (CCC), the National Labor Relations Board (NLRB), the Rural Electrification Administration (REA), the Resettlement Administration, (RA), the National Resources Planning Board (NRPB), and the National Youth Administration (NYA).

One New Deal agency that won special attention from government artists was the Civilian Conservation Corps. Created in 1933, the CCC employed jobless young men on work projects such as planting trees, stocking lakes and rivers, and building shelters, trails, and campgrounds. It had a close relationship with many of the federal art projects. Federal Theatre troupes entertained and Federal Art Project workers gave drawing classes at CCC

camps. Several PWAP paintings and Treasury Section post office murals extolled the value of CCC reforestation, fire fighting, soil conservation, and wildlife husbandry work.

Among works with a CCC theme are a WPA poster by the Chicago Art Project's Albert Bender, a photograph by Wilfred J. Mead, and a drawing by CCC member Tom Rost, Jr. (figs. 69–71). Sometimes, as in Bender's poster, which was designed to recruit men for the CCC, artists extolled the benefits CCC discipline, food, medical care, and education. At other times, as in Rost's drawing, the artists were more concerned with leaving a visual record of life in the camps. Mead, who was the Corps's official photographer, captures the romantic adventurism so appealing to potential enrollees as well as the healthful benefits that volunteers might receive from serving with the CCC. His image is strikingly like the Bender poster: Both suggest young men consider the value of time spent with the Corps.

67
"USA Work Program WPA"
By an unknown artist, 1936
Photolithograph
National Archives, Publications of the
U.S. Government (Y3w 89²: 8w89)

68
Mural panel for PROFESSIONS AND INDUSTRIES OF HYDE PARK
By an unknown photographer, 1941
National Archives, Records of the Public Buildings Service
(121-PS-8261)

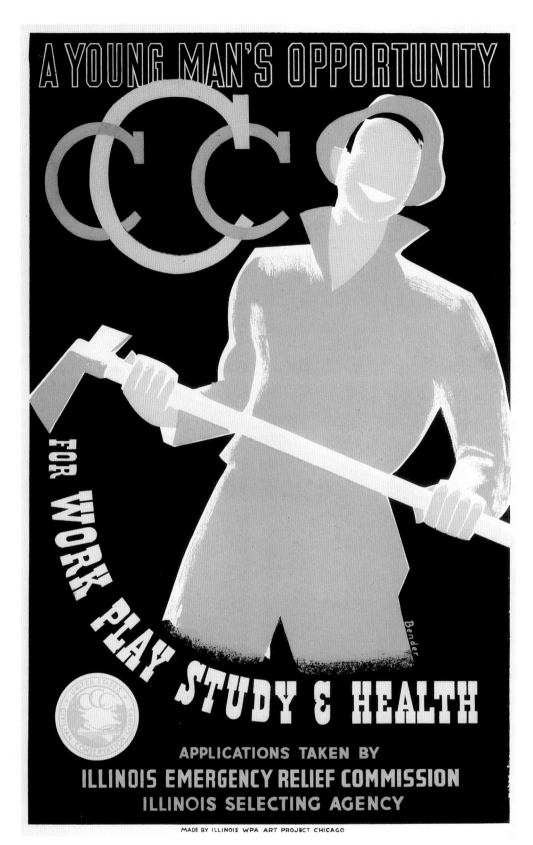

69
"C.C.C. A Young Man's Opportunity for Work Play Study & Health"
By Albert Bender, Chicago Federal Art Project, WPA, ca. 1937
Silkscreen
Prints and Photographs Division, Library of Congress (B WPA III.B46 l)

70

"The slogan of the Civilian Conservation Corps is 'We can take it!' Building strong bodies is a major CCC objective. More than half the enrollees who entered CCC the last year were seventeen years of age. Work, calisthenics, marching drill, good food, and medical care feature the CCC health program."

By Wilfred J. Mead, Civilian Conservation Corps, undated
National Archives, Records of the Civilian Conservation Corps
(35-G-830)

71
SUNDAY PAPERS, CAMP HONEY CREEK, WAUWATOSA, WISCONSIN
By Tom Rost, Jr., Wisconsin Civilian Conservation Corps, undated
Ink and wash on paper
Franklin D. Roosevelt Library, National Archives and Records Administration
(MO 56-213)

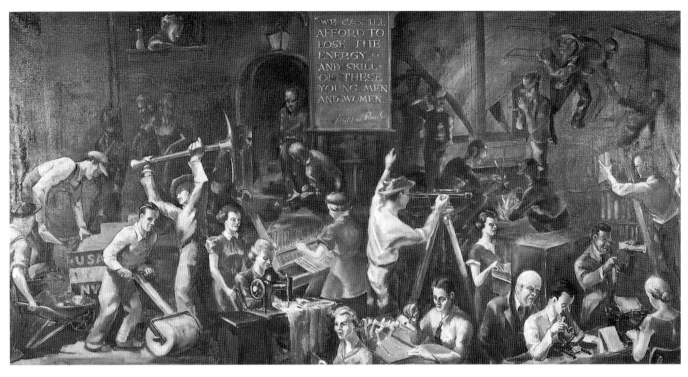

72

Painting depicting the activities of the National Youth Administration

By Alden Krider, Kansas National Youth Administration, 1936

Oil on canvas

Franklin D. Roosevelt Library, National Archives and Records Administration (44-107-1)

Another agency that New Deal artists memorialized was the National Youth Administration, which was established in 1935. Like the CCC, the NYA provided jobs for young adults, especially college students, many of whom found themselves without work, direction, or hope. Eventually the NYA employed 4.5 million people. Unlike the CCC, the NYA sought to employ a broader group of young men and women than those who might be drawn to the rugged quasi-military life of a CCC camp. In 1936 Alden Krider, an NYA artist, painted the story of the NYA for an exhibit at the Kansas State Fair (fig. 72). The painting's shadowy background represents some of the problems and temptations faced by young people during the Depression: crime, poverty, gambling, and homelessness. In the foreground, Krider shows the various types of beneficial employment provided by the NYA. President Roosevelt's words establishing the NYA in 1935 are also prominently displayed.

Also in 1935, the New Dealers created the Resettlement Administration to attack rural poverty. It provided impoverished farmers, especially those affected by the droughts of the 1930s, with low-cost loans, equipment, and education about soil conservation. It was also responsible for building several planned model communities, including the famous "Greenbelt" towns in Maryland and Wisconsin. In his 1937 poster "Years of Dust" (fig. 73) Ben Shahn contrasted an image of an impoverished pre-New Deal sharecropper trapped by the "Dust Bowls" with the Resettlement Administration's bold actions. Shahn traveled through Arkansas in 1935 while working as a photographer for the Resettlement Administration. His posters, prints, and photographs often championed the more progressive New Deal programs. His graphic work, he hoped, would "explain in posters to the people who need it what is being done for them and to the others what they are paying for."

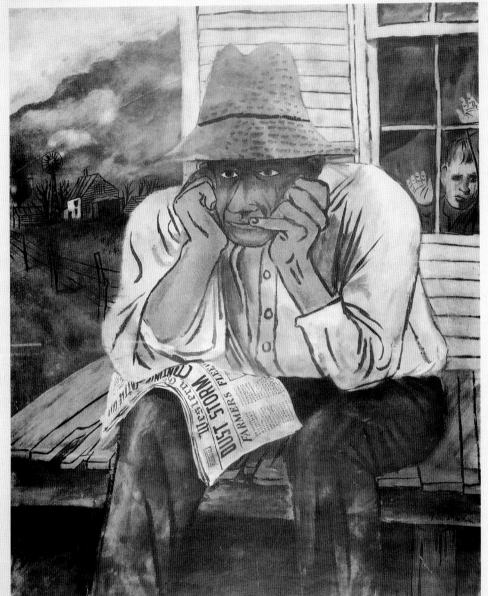

73
"Years of Dust"
By Ben Shahn, Resettlement Administration, 1937
Photolithograph
Franklin D. Roosevelt Library, National Archives and Records Administration
(MO 90-10)

74

ELECTRIFICATION

By David Stone Martin, Treasury Section of Fine Arts, 1940
Tempera on cardboard
Fine Arts Collection, General Services Administration
(FA4703)

The electrification of America was an-
other topic for project artists anxious to thank
the New Deal. In the early 1930s, 9 out of
10 American farms had no electricity. One of
the New Deal's major achievements was
bringing electrical power to rural America,
and this success was most famously demon-
strated in the Tennessee River Valley. Through
the Tennessee Valley Authority (TVA), the
federal government built a series of huge
hydroelectric dams for flood control and to
provide power to the countryside. Artist David
Stone Martin memorialized this accomplish-
ment in his mural for the post office in Lenoir,
Tennessee (fig. 74). His painting shows a group
of workers erecting power lines. The intersec-
tion of lines, towers, and ropes create ab-
stract angles that add interest and energy to
the image, while the workers convey a sense
of collective strength and power.

When power companies refused to run
lines into rural America, claiming it was not
economically feasible, another New Deal
bureau, the Rural Electrification Administra-
tion, sponsored cooperatives that received
low-cost government loans for developing
electric power and put the unemployed to
work running power lines into the country-
side. Photographer Peter Sakaer artfully doc-
umented one Louisiana co-op bathed in the
light it had brought to the region (fig. 75).
For decades after the 1930s, REA co-ops
remained common sights in small towns
across the United States.

The Federal Theatre was more willing
than the other arts projects to take on contro-
versial issues. In fact, the FTP developed a
new genre devoted to dramatizing contem-
porary social and political issues. Called "Liv-
ing Newspapers," these plays wove newspaper
stories, speeches in Congress, sociological
studies, and court records into scripts on a
variety of subjects ranging from agricultural
policy (**Triple A Plowed Under**) to organized
labor and the courts (**Injunction Granted!**) to
a history of syphilis (**Spirochete**). Productions
used music, lighting, dialogue, and projected
images such as maps, photographs, or brief

75
"Rural Electrification Administration co-op office. Lafayette, Louisiana. 1939"
By Peter Sakaer, Rural Electrification Administration
National Archives, General Records of the Department of Agriculture (16-G-112-2-S-3522A)

film clips to lend dramatic energy to whatever subject was under scrutiny. Another innovation was the "Voice of the Living Newspaper," an offstage narrative voice who spoke to the audience through loudspeakers and who made transitions, set dates and places, or posed questions to characters on stage.

Several "Living Newspapers" portrayed the New Deal sympathetically. Arthur Arent's **Power**, for example, provided background and justification for the TVA. **Power** took as its subject the history and spread of electricity to the masses and ran in New York City for 5 months in 1937. The play begins with a blackout in a major city. A befuddled central character, the everyman, Angus K. Buttonkooper, wonders why this had happened when his power bill is so high. As the play develops, Mr. Buttonkooper (and the audience) is educated about the growth of

monopolies in the power industry. In one of the climactic scenes, lawyers argue before the Supreme Court the constitutionality of government-provided electric power (fig. 76). In another, as photographs of hydroelectric dams flash dramatically in the background, a group of farmers and workers march on stage and sing "The TVA Song," praising government ownership of electric power. It goes in part:

> All up and down the valley
> They heard the great alarm;
> The government means business
> It's working like a charm
> Oh, see them boys a-comin'
> Their government they trust,
> Just hear their hammers ringin'
> They'll build that dam or bust.

The most famous and popular example of the "Living Newspapers" was **One-Third of a Nation**. After President Roosevelt declared

76
Scene showing argument before the Supreme Court on TVA from POWER
New York City Federal Theatre Project, WPA, 1937
By an unknown photographer
National Archives, Records of the Work Projects Administration (69-N-13146)

in a speech that "one-third of a nation" was "ill-housed, ill-clad, ill-nourished," the FTP seized on the President's phrase for the title of its play about housing. **One-Third of a Nation** opened in New York City in 1938 and then played in 10 cities across the country (fig. 77). The FTP estimated that some 200,000 people saw performances. Once again employing the character of Mr. Buttonkooper as a device to educate the audience, the play's realistic portrayal of urban slum conditions (including sets designed from actual tenements) made it a hit. But when it endorsed specific housing legislation and used quotes from Congressmen opposed to public housing in the script, several Senators attacked the play.

Theatre Project casts occasionally took on such New Deal critics with humor. The musical review **Sing for Your Supper**, for instance, pokes fun at the Federal Theatre and at politicians as well as satirizes contemporary events. But in the "leaning on a shovel" skit (fig. 78) WPA workers musically dispute charges that work relief promoted lazy workers who were paid for "shovel leaning." In one stanza they sing:

> When you look at things today
> Like Boulder Dam and TVA
> And all those playgrounds where kids
> can play
> We did it—by leaning on a shovel!

Those opposed to the New Deal attacked the projects for using the arts to promote Roosevelt's agenda and especially criticized the FTP for using federal tax dollars for political gain. When New Dealers responded that they were only providing factual information to the public about the critical issues of the day, FDR's opponents replied that they were disseminating propaganda. One newspaper declared that **Power** was "a long . . . cunning arrangement of blatant political propaganda." A Senate committee investigating the projects in 1938 accused them of supporting a variety of liberal and left-wing political causes. One conservative southern Senator claimed that federal money for the arts was money appropriated "for the purpose of eliminating us" from Congress.

Clearly, some New Deal artists were occasionally guilty of blatant advocacy, although it does not appear that this was usually orchestrated by the White House or that there was any federal conspiracy to create propaganda for the New Deal. Instead, most artists saw themselves as expressing admiration for a government that was fulfilling at least some of their ideals. "We were all very ardent New Dealers," recalled California painter Edward Biberman, "and when we found [New Deal policies] reflected in the art programs we were even more enthusiastic." Another California New Deal muralist put it this way: "If we understand our role as Government workers, our duty is to serve the Government. By conforming ourselves to the program, our contributions in public buildings must be understood by the people at large." While "conforming . . . to the program" may sound somewhat ominous, for most New Deal artists it simply meant working within the broad guidelines set by the various projects and offering up artistic creations that would be useful to the government as well as its citizens.

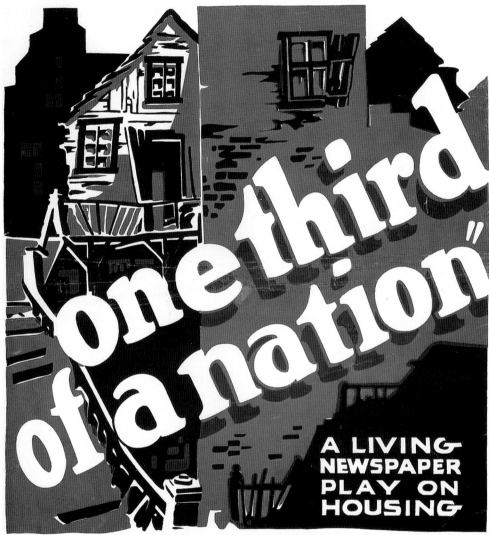

77
Poster for Portland, Oregon, production of ONE-THIRD OF A NATION
By an unknown artist, 1938
Silkscreen
National Archives, Records of the Work Projects Administration
(69-TP-160)

78
"Leaning on a shovel" skit from New York City
production of SING FOR YOUR SUPPER
New York City Federal Theatre Project, WPA, May 1939
By an unknown photographer
National Archives, Records of the Work Projects Administration
(69-TS-737-923-106)

79

SOUTH OF CHICAGO

By Todros Geller, Illinois Federal Art Project, WPA, 1937

Wood engraving

Franklin D. Roosevelt Library, National Archives and Records Administration

(MO 56-314)

A ctivist Arts

A variety of politically active artists worked for the New Deal projects. United by a desire to use art to promote social change, these artists sympathized with the labor movement and embraced other left-wing political causes. Of course, artists were choosing themes of social concern long before the creation of the arts projects, but many playwrights, painters, printmakers, and photographers used the projects to explore subjects such as the social inequalities in American life, the plight of the poor, the lives of workers, and the threat of fascism and war. In the extreme, such socially conscious art became a crude weapon aimed only at exposing capitalism's abuses and exalting the struggles of the working class. In other instances, the commitment to use art to create a better world resulted in "social realist" works that caught the grim reality of Depression-era America. The Federal Art Project could usually accommodate moderate social realism. But more controversial political statements, espe-

1920s, and artists expressed these contradictions in their writing, printmaking, painting, and photography. The Depression also politicized the American artistic and intellectual community. The economic crisis created a highly charged atmosphere where artists embraced and debated a variety of left-wing ideologies ranging from New Deal liberalism to socialism to Trotskyism to Stalinism. Many, even some left-liberals, favorably contrasted the Soviet Union's centrally planned economy with the unemployment and economic chaos they saw at home. Others saw Russia as the only bulwark against the growing threats of German and Italian fascism. Marxist writings enjoyed a resurgence, as did membership in the Communist Party (CP).

Most left-wing intellectuals balked at actually joining the CP because of its disdain for intellectual pursuits and its demands of absolute loyalty to the party line. But many also viewed Marxism as "radical humanism" while admiring the party's organization, disci-

> "We, as artists, must take our place in this crisis on the side of growth and civilization against barbarism and reaction, and help to create a better social order."
>
> —Peter Blume, "The Artist Must Choose," 1936

cially in public art such as murals or Federal Theatre productions, became ammunition for the projects' enemies to use against them.

Several influences during the 1930s pushed American artists and other intellectuals toward creative expressions that were socially concerned. Certainly the Depression and its attendant unemployment, poverty, and despair was a major factor. The Depression made the gap between the promise and reality of American life more evident than it had been during the prosperous

pline, and sense of purpose. The popularity of discussion groups, such as the John Reed Clubs sponsored by the CP, added to this heady sense of political engagement and gave artists a place to go to discuss political and artistic theory. There they debated the burning artistic issues of the day such as the relationship between art and politics and the use of art as propaganda. Especially after 1935, when the Communist Party launched its "popular front," designed to broaden its appeal, ideological lines blurred as left-wing

activists used patriotic rhetoric and symbols, hoping to create mass political movements around issues such as housing, the rights of labor, and the threat of fascism.

One of the most admirable aspects of the WPA projects was Harry Hopkins's insistence that the political philosophy of arts project workers play no role in their hiring, promotion, transfer, or dismissal. For the most part, project administrators followed these rules, although there were occasional well-publicized accusations of supervisors punishing employees for their politics. In theory at least, the no-politics ban extended to project workers who were not to engage in political activities on the job.

But of course, the activist-artists who filled the ranks of the arts projects brought their views to work with them. This mix made many of the large city projects, where most of them worked, hotbeds of political activity. Left-wing project employees not only painted, acted, and wrote, they walked picket lines, published newspapers, and led sit-in strikes (figs. 80, 81). Project artists discussed and worked for causes such as industrial unionism, civil rights for black Americans, and support for the anti-fascists in the Spanish Civil War. The most political of WPA artists formed labor organizations of their own, establishing groups such as the Artists Union and American Artists Congress, which protested WPA personnel cuts and lobbied for permanent government arts programs. Among painters and muralists, the art of Mexican muralists, most prominently Diego Rivera, was held out as an example of government-sponsored art that had a political or even revolutionary purpose.

Such political awareness did not necessarily dictate the subject an FAP artist chose to paint or prescribe the theme of a Federal Theatre play, but the politically charged

atmosphere did create a context for some of the choices made by project artists. And social realist art often, but not always, advocated a political point of view. Much of it aimed simply at documenting the grittier aspects of life in Depression-era America. Like American Scene painting, it shared an interest in American subjects, but social realism did not shy away from the harsh realities of the 1930s or romanticize small-town life. Instead, it concentrated on dark images of factories and cities and on the poverty of the countryside. Raphael Soyer, for example, urged his fellow artists, "Yes, paint America, but with your eyes open. Do not glorify Main Street. Paint it as it is—mean, dirty, avaricious."

Two FAP prints, Todros Geller's **South of Chicago** and Mabel Wellington Jack's **Coal Hopper at 14th Street** illustrate this approach (figs. 79, 82). Geller's small woodblock print, made while he worked for the FAP in Chicago, shows a bleak industrial landscape in the winter. Several factories belch smoke into the sky while, in the foreground, two men

80
"Lookit, I'm paying 55 cents for standing room and a week ago I could have seen the same dancers on the picket line for nothing"
By Don Freeman, New York City Federal Art Project, WPA, 1937
Reproduced from FEDERAL THEATRE magazine
National Archives, Records of the Work Projects Administration

shovel snow already dirty from the smoke. The print makes no overt political declaration, but Geller's view of industry and city life is brooding and pessimistic. Moreover, shoveling snow was a common "make work" job provided for the unemployed during the 1930s. It takes only a small leap to see the social criticism implied by the juxtaposition of factories unable to provide work to all and those who toil at menial tasks outside. Jack's lithograph, done for the New York City FAP, is a view of yet another factory darkly silhouetted either at early morning or at dusk. Both prints stand in sharp contrast to more benign images of city life such as Ceil Rosenberg's Chicago winter pictured earlier (fig. 20).

81
"Friday the 13th Demonstration at Times Square," ca. 1937
National Archives, Records of the Work Projects Administration

An example of a social realist work with a more obvious, even crude, political point of view is Harry Gottlieb's **Three Lane Traffic** (fig. 84). Gottlieb's lithograph underscores the class differences within American society. On the left, workers walk a picket line in the rain. Behind them, wealthier individuals are partially shielded from the storm. In the far background are the rich, pictured stereotypically as bloated, cigar-smoking plutocrats, warm and comfortable. Gottlieb was a founder and president of the Artists Union. He also participated in the American Artists Congress, an organization that sponsored political and artistic discussions, organized exhibitions, and issued manifestos on the social and political topics of the day. It is interesting to note that Gottlieb made a similar print entitled **Neither Rain nor Snow** in which the focus is on the picketers, and the rich, dry businessmen have been left out entirely.

Another political work, this one done with more skill and subtlety, is Ben Shahn's **Lest We Forget** (fig. 83). Shahn's painting recalls the plight of landless farmers in the American South and the organizing efforts of the Southern Tenant Farmers' Union in the mid- and late 1930s. Marked Tree is a small Arkansas town that was the site of antiunion violence. Shahn traveled through Arkansas with his wife, New Deal artist Bernarda Bryson Shahn, in 1935 while working as a photographer for the Resettlement Administration, and many of his photographs later served as inspiration and studies for his drawings and paintings. The quotation on the bottom of the page calling for a "farmer-worker alliance" is from Rexford Tugwell, the head of the Resettlement Administration. When Tugwell left his position in 1937, his staff presented him with a volume of sketches, recordings, photographs, and other memorabilia from his time in office, including Shahn's drawing.

82
COAL HOPPER AT 14TH STREET
By Mabel Wellington Jack, New York City Federal Art Project, 1937
Lithograph
Franklin D. Roosevelt Library, National Archives and Records Administration
(MO 56-261)

83

LEST WE FORGET

By Ben Shahn, Resettlement Administration, 1937

Gouache and watercolor in bound volume

Franklin D. Roosevelt Library, National Archives and Records Administration

(MO 74-311)

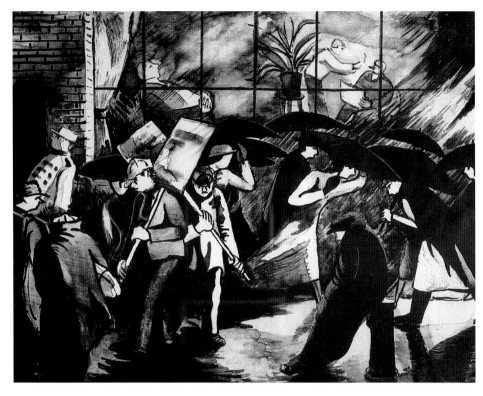

84
THREE LANE TRAFFIC
By Harry Gottlieb, New York City Federal Art
Project, 1937
Lithograph
Franklin D. Roosevelt Library, National Archives
and Records, Administration (MO 56-256)

Another political artist, Rockwell Kent, painted two murals in the Post Office Department Building in Washington, DC. One of these celebrated the first airmail delivery between Alaska and Puerto Rico. In his mural depicting the arrival of mail in Puerto Rico, Kent showed a woman with an open letter in her outstretched hand (fig. 85). On the letter Kent painted in an Eskimo dialect, "To the people of Puerto Rico, our friends! Go ahead, let us change Chiefs. That alone can make us equal and free." (fig. 86) The message might have gone unnoticed except that Kent, a dedicated Communist who appears to have been seeking a confrontation with the government, telephoned a reporter who publicized the quote. An arctic explorer translated the letter for the Post Office Department, which demanded that Kent alter the words and threatened to withhold his fee. Kent refused, and after several attempts at substituting a more acceptable text, and after threatening to paint out the writing on the letter, the government paid Kent his commission. Kent's controversial message is still visible today.

The New Deal documentary photographs that ventured into political commentary remain some of the most compelling visual documents of the decade. These images of rural and urban poverty laid bare the economic exploitation of farm workers, uncovered the poor living conditions in city tenements, and put a human face on the Depression. Dorothea Lange's photograph of a migrant family living in a trailer depicts an America filled with poverty and hopelessness while still preserving her subjects' dignity and humanity (fig. 87). A photograph by Arnold Eagle and David Robbins from the WPA photography series "One-Third of a Nation" takes a hard look at the urban poverty of the Great Depression by showing a small boy posed with his tricycle in the midst of slum (fig. 88).

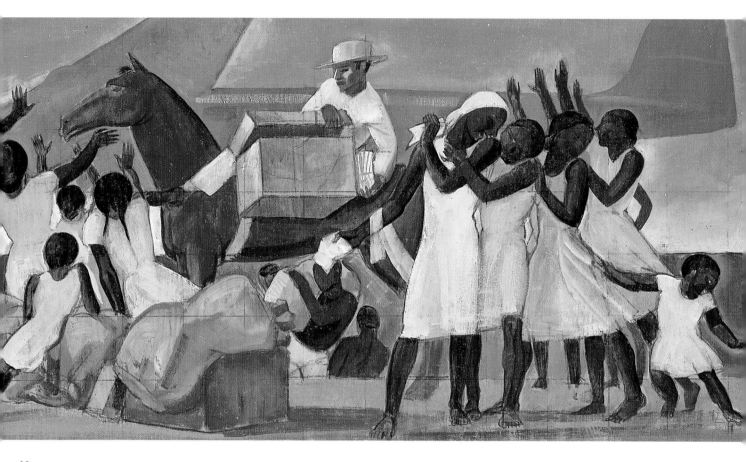

85

MAIL SERVICE IN THE TROPICS

By Rockwell Kent, Treasury Section of Painting and Sculpture, 1937

Pencil and oil on plywood

National Museum of American Art, Smithsonian Institution, transfer

from General Services Administration (1982.86.2)

86

Detail from completed MAIL SERVICE IN THE TROPICS

By an unknown photographer

National Archives, Records of the Public Buildings Service

(121-PS-1337)

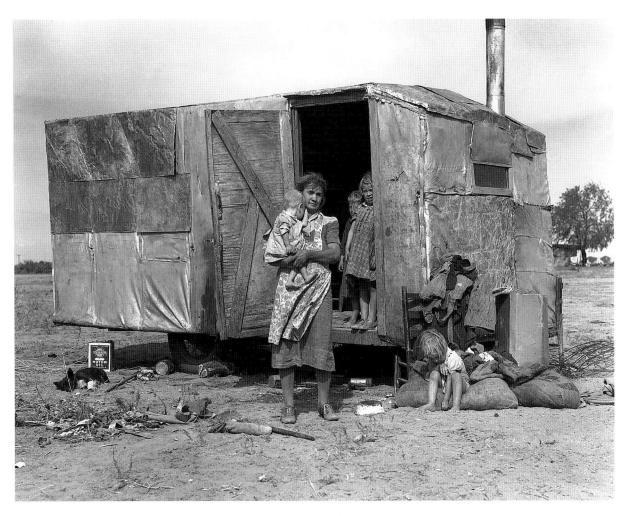

87
"Children in a democracy. A migratory family living
in a trailer in an open field. No sanitation, no water.
They come from Amarillo, Texas."
By Dorothea Lange, Bureau of Agricultural Economics, November 1940
National Archives, Records of the Bureau of Agricultural Economics
(83-G-44360)

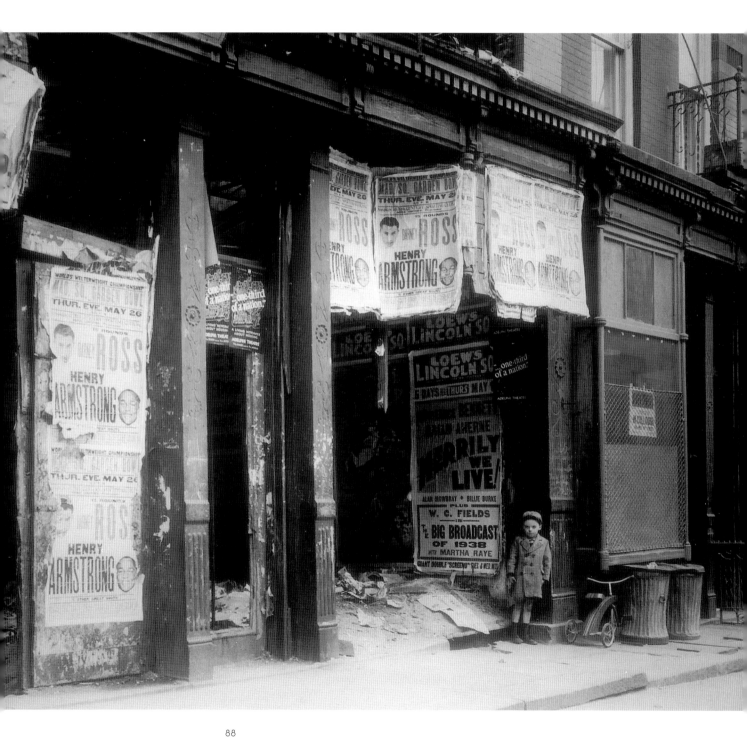

88
From the "One-Third of a Nation" series

New York City

By Arnold Eagle and David Robbins, New York City Federal Art Project,

May to August 1938

National Archives, Records of the Work Projects Administration

(69-ANP-1-2329-325)

Ironically, one of the many torn posters on the wall announces a screening of **Merrily We Live.** These two photographs, unlike FSA classics like Lange's "Migrant Mother" or Arthur Rothstein's "Dust Storm, Cimmaron County, Oklahoma," did not become icons of an era, but they, too, were instrumental in exposing the human pain of the Great Depression to a wider audience. To a certain extent, such images have come to symbolize the entire Depression experience in America.

Most Federal Theatre Project productions were classical dramas, vaudeville, or light comedy. But FTP Director Hallie Flanagan also encouraged dramatists and directors to experiment and especially to address the social and political issues of the day. Fostering experimental and socially relevant theater, however, also embroiled the FTP in several very public controversies. These "plays with bite," as one historian has called them, often served as prime examples of what enemies of the Federal Theatre Project saw as radical influences within the project and made the FTP the lightning rod for opponents of government-sponsored art within Congress.

Many of the FTP's socially relevant plays dealt with labor issues, one of the nation's most controversial issues during the 1930s. **Altars of Steel** described what happened to a small community when a large corporation bought a small southern plant. It probed the steel industry's use of secret police to stifle unionism and the impact of labor violence. **Let Freedom Ring** told the story of striking southern textile workers. **Injunction Granted!,** a "Living Newspaper," related the history of American labor and described how organized labor had been blocked by the courts. Even Hallie Flanagan thought its "agit-prop" approach bordered on the "hysterical," although she allowed its production to continue. **Altars of Steel** sparked controversy

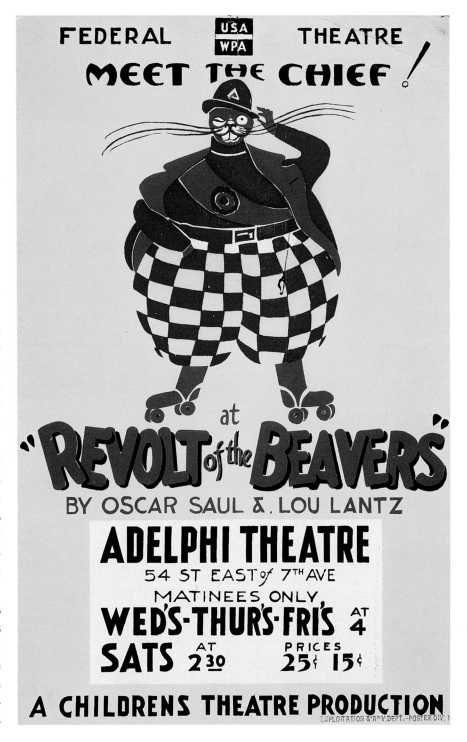

when it opened Atlanta, Georgia, as did other such plays when they were produced across the country.

The most famous of these disputes involved the premiere of Marc Blitzstein's **The Cradle Will Rock** (fig. 91). The musical drama's story line describes a union-organizing drive in the mythical city of Steeltown, U.S.A. Its characters included a handsome

89
Poster for THE REVOLT OF THE BEAVERS
By an unknown WPA artist, 1937
Silkscreen
Music Division, Library of Congress

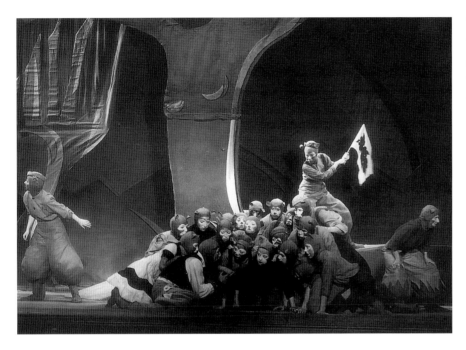

90

"The Beavers gather under Oakleaf's (Jules Dassin) flag to discuss the overthrow of the Chief." A scene from THE REVOLT OF THE BEAVERS.

By an unknown photographer
National Archives, Records of the Work
Projects Administration (69-TS-24J-400-3)

union organizer named Larry Foreman, a rich industrialist named Mister Mister, and a streetwalker aptly named The Moll. Foreman and The Moll, along with some of the town's most best citizens, all members of the anti-union "Liberty Committee," end up in night court, the victims of a police sweep designed to incarcerate union organizers. As the show unfolds, the representatives of respectability seek to demonstrate that they should be released but end up proving only that they have been thoroughly corrupted by Mister Mister's power and wealth. The climax of the play is a dramatic confrontation between the forces of good and evil personified by Foreman and Mister Mister. The play ends with a stirring massed chorus of union supporters rescuing Foreman while singing the play's title song.

The play's opening, produced by John Houseman and directed by Orson Welles, was to have been one of the most important Federal Theatre premieres of 1937. A series of violent real-life strikes, however, made its subject political dynamite. In early June the

WPA, claiming budgetary problems, decreed that no new productions could open before July 1. But Welles and Houseman went ahead with their final dress rehearsals anyway, and on June 16, opening night, WPA officials locked out the cast and audience. Houseman then rented another theater, and the audience and cast marched to the new hall, where composer Blitzstein played the score on a piano, and cast members performed their parts from the audience to avoid violating union rules about "performing" in a non-WPA show. Throughout the dispute, Houseman and Welles cried government censorship, but it remains unclear why the WPA initially refused to allow the show to open on time. Today the incidents of June 16 have passed into theatrical legend.

The great majority of the children's plays produced by the Federal Theatre were titles such as **Pinocchio** and **The Emperor's New Clothes.** This light fare was warmly received by critics and audience alike. **The Revolt of the Beavers,** however, stirred political passions from the moment it premiered in New York City (figs. 89, 90). In the play, two small children are transported to "Beaverland," where society is run by a cruel beaver chief. "The Chief" forces the other beavers to work endlessly on the "busy wheel," turning bark into food and clothing, then hoards everything for himself and his friends. With the help of the children, a beaver named Oakleaf organizes his brethren, overthrows The Chief, and establishes a society where everything is shared.

The show played to packed houses during its brief New York City run, but its message drew fire. Supporters claimed that, like most fairy tales, it was simply a morality play—a tale of "good guy versus bad guy" reminiscent of Robin Hood, as one of the playwrights, Lou Lantz, put it. Critics were less

generous. A New York City Deputy Police Commissioner refused the WPA's offer of free tickets for children in the Police Athletic League, claiming the play preached "doctrines directly opposed to . . . democratic principles." Officials of the Boy Scouts of America threatened to investigate the show for possible "departures" from their ideas of "citizenship." **New York Times** theater critic Brooks Atkinson labeled **Revolt** "Marxism à la Mother Goose."

The Federal Theatre also received criticism about their production of **It Can't Happen Here** (figs. 92, 93). Based on a bestselling novel by Sinclair Lewis, the drama is set after a fascist takeover of America and describes life under a dictatorship similar to the ones ruling Germany and Italy. On October 27, 1936, the Federal Theatre Project took advantage of the interest in Lewis's book and launched 22 simultaneous openings of the play across the country, including Yiddish, Spanish, and all-black productions (fig. 94). By the end of its run, **It Can't Happen Here** had been seen by almost 500,000 people nationwide. In some cities, local authorities refused to allow the play to open because of its controversial content. Republicans called the play New Deal propaganda and charged that the date for the show's mass opening had been selected to whip up support for Democrats in the 1936 elections.

With the threat of war looming in Europe, several Federal Theatre Project productions adopted antiwar themes. Paul Green's and Kurt Weill's **Johnny Johnson** was set in the trenches of World War I (figs. 96, 97). Its young title character goes off to war reluctantly after his girlfriend refuses to marry him if he does not enlist. Once in the Army, he understands the futility of war and then unsuccessfully strives to prevent further slaughter. He is eventually declared insane for his

actions. In Maria Coxe's **If Ye Break Faith,** six dead unknown soldiers from World War I are awakened and given the chance to go back and tell the world of the horrors of war. Each returns to his country, and each, in turn, fails to convince his countrymen to choose peace. A set design for the New Orleans production of **If Ye Break Faith** shows war to be a mix of blind patriotism and greed benefitting wealthy industrialists (fig. 95).

91
Playbill for THE CRADLE WILL ROCK
By Marc Blitzstein, Federal Theatre Project, WPA, 1937
Music Division, Library of Congress

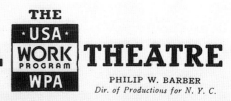

THE
· USA ·
FEDERAL **WORK PROGRAM** **THEATRE**
WPA
HALLIE FLANAGAN PHILIP W. BARBER
Director *Dir. of Productions for N. Y. C.*

PROJECT 891

John Houseman, Producer

PRESENTS

THE CRADLE WILL ROCK

By

MARC BLITZSTEIN

Production by ORSON WELLES
Conductor, LEHMAN ENGEL

Sets and Costumes by ED SCHRUERS
Lighting by FEDER
Associate Producer, TED THOMAS

THE CAST

Moll	Olive Stanton
Gent	George Fairchild
Dick	Guido Alexander
Cop	Robert Farnsworth
Clerk	Clifford Mack
Members of The Liberty Committee:	
Editor Daily	Bert Weston
President-Prexy	Hansford Wilson
Yasha	Edward Fuller
Dauber	Warren Goddard
Dr. Specialist	Frank Marvel
Rev. Salvation	Edward Hemmer
Druggist	John Adair
Mr. Mister	Will Geer
Mrs. Mister	Peggy Coudray
Junior Mister	Hiram Sherman

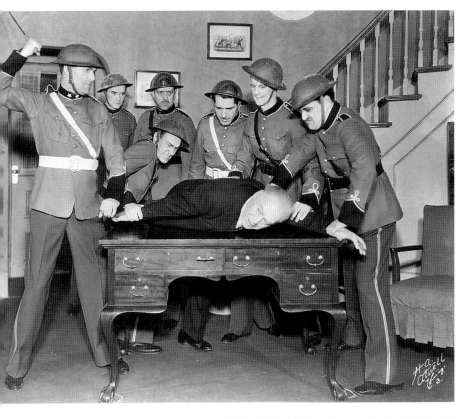

92

"Shad Ledue (E. M. Johnstone) leader of the Corpos administers a beating to Doremus Jessup (Oscar O'Shea) a liberal Vermont newspaperman who has been writing against military dictatorship of Pres. "Buzz" Windrip. Sinclair Lewis, It Can't Happen Here. Blackstone Theatre, Chicago." October 1936

National Archives, Records of the Work Projects Administration (69-N-17215)

93

Design for poster for It Can't Happen Here
By an unknown WPA artist, 1936
Pencil, gouache, and colored pencil on board
National Archives, Records of the Work
Projects Administration (69-TSR-132(3))

It is easy to look back on at the political climate of the 1930s and only notice the heat. This is especially true of the politics surrounding the art projects as well as the more general political environment. The rhetoric of left-wing artistic commitment as well as the controversies between government and artists encourage a view that the government and the socially conscious artist were constantly pitted against one another in a series of noisy confrontations between "red" artists and inflexible government officials. Such a view, however, would be an overstatement, although it was true in some cases. The fact that the projects created so much politically tinged art meant that the New Deal atmosphere was often congenial to social realist paintings, socially critical documentary photography, and politically relevant theater.

The projects occupied the broad center of an artistic activism that encouraged such creative explorations. Within limits, project administrators gave artists under their direction freedom to experiment with politically or socially charged themes. Sometimes, as with Hallie Flanagan, they even encouraged such experiments. Undoubtedly, there were artists who pushed these limits, and the public controversies that ensued can tell us a great deal about the interaction between artist and the government as art patron. But generally, activist-artists found the arts projects a supportive place to work.

‑34‑

ערשטער אקט 6טע סצענע

(דער בראדקעסט האלם נאך אן . מיר זעען די אין הויז
פון דאריאוס דושעסאם הערט מען זיך צו בײ א
קינדער ראדיא. דאריאוס און לאריגדט הערן מים
אויפגערעגמער דערוואכמונג. לאריגדט האלם זיך
קוים אין, נישם אויסצושימען איר געגנערשאפט)

ראדיא
(באזי שטימע)

אבער אלע מינע פאליסים, אינגעגדיסע און אויסלעגדישע, שטיצן זיך אויף
אין פרינציפ—מיסענפאנעמעלי צו העלפן, אז אלע צוטראמעגע און בעלידיקטע
זאלן הערן גליבע מים יעדן! שעספירקיר אין מים יעדן און געשאפטען אינטער—
נאצינאלען אידישן באנקיר: אין דערמים וואלם איך באדארפם דערענדיגן
און זאגן ,,זיים גענונט, מינע ליבע פרינ‑ים'' ..

לאריגדט

א שלאגג פאר א שכן.

ראדיא
(מיט הויכער ...)
אן אומגליקלאכע אספירונג איז פארגעקומען אין דעם שינעם, קלינעם
שמעטעלע פארט ביולא, פערמאנמ.

(לאריגדע און דאריאוס הערן זיך צו מים מער אויף‑
מערקזאמקימ...אויף דעראויף האבן זי געהארט)

א זיער ליטישער, אנגעזעענטר קרעמער פון דער שטאט איז שטערבלאך
פארוואונדעם געווארן אין א קריגער—מיגע שואגיס פרואנז מארגן די
שולד אויף די קארפאס. איך האב געהימע אינפארמאציע וועגן דעם מאס איז
ווירקלאך געשען, און דאס וואס מען רין די קארפאס. אבער, ווען איך וואלם נישם
געוואוסם דעם אמת, און ווען זועלכער ס'איז קארפאס וואלם ווירקלאך געמאן
שולדיק, וואלם איך אים פאריאגם אפילו ווען ער וואלם געזעסן מין אינצינקער
פארבליבענער נאכמאלגער. ער שטים בעשריבן אין די הילקע שריפם
,,מאריס אויב עפיס שלעכמם געשעם צום קלעגסמן פון זי‑‑...''
(לאנגזאם פאראמאכם די ראדיא מים א רים, כאמש דאריאוס
דאריאוס
מעי, ב'וויל הערן דאס איבעריקע!
לאריגדט
(בשעת ער גים צו דער ראדיא)
לאז צורו.
(דאס עלעקטרישע גלעקל קלינגם)
דאריאוס
ער האם ווירקלאך געמאן אלץ, וואם ער האם געקאנט...
(דאריאוס גים צו דער מיר)
לאריגדט
און דאס איז אלץ וואם ער וועם מאן"‑ ‑ ‑
(דאריאוס עפנט די מיר, דזשוליען פאלק ארין)

94

Page from the script for IT CAN'T HAPPEN HERE (in Yiddish)

By Sinclair Lewis and John C. Moffitt, Federal Writers' Project, 1937
National Archives, Records of the Work Projects Administration

95

Set design for New Orleans production of
IF YE BREAK FAITH

By William Perkins, New Orleans Federal Theatre
Project, WPA, 1938
Pencil on paper
National Archives, Records of the Work
Projects Administration

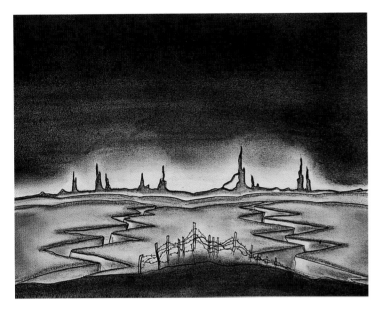

96
Set design for JOHNNY JOHNSON
By Frederick Stover, Los Angeles Federal Theatre Project, 1937
Ink, chalk, and pencil
National Archives, Records of the Work Projects Administration
(69-SC-7A)

97
Scene from Los Angeles production of JOHNNY JOHNSON
By an unknown photographer, May 1937
National Archives, Records of the Work Projects Administration
(69-TC-SCA-102-1)

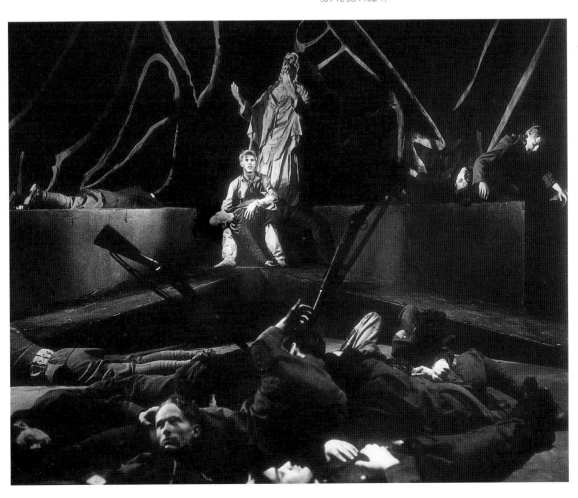

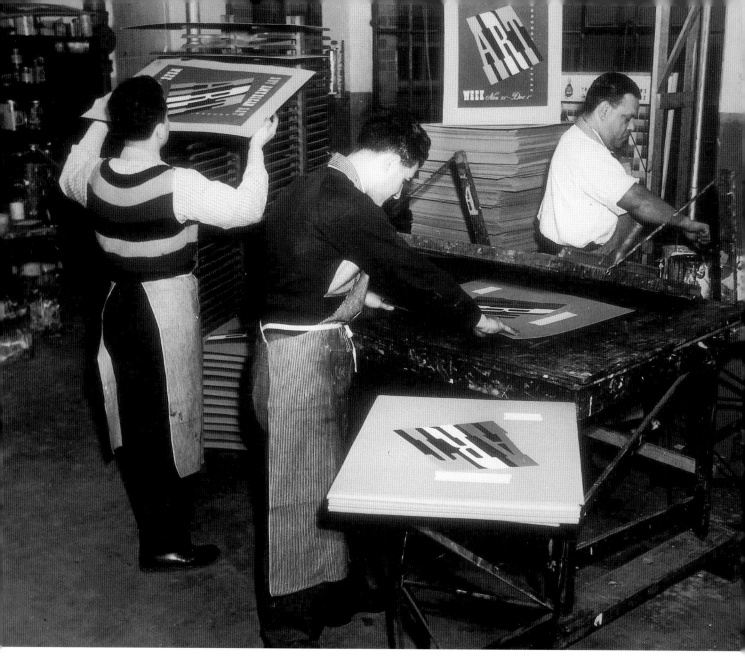

98
Printers making serigraph posters for New York City Art Project
By Rose, 1940
National Archives, Records of the Work Projects Administration
(69-AN-858-5374-2)

*U*seful Arts

Those who ran New Deal art projects were often artists themselves. But they were artists who believed art should not be limited to an elite. They refused to reward only those talented enough to paint museum-quality work or perform on a New York concert stage. Most New Deal artist-administrators believed deeply that the projects had a responsibility to explore art's many expressions, to reach out to as many Americans as possible, and to put art to practical uses. This philosophy, along with the numbers of people employed, allowed for great variety in the artistic endeavors the projects undertook, including teaching art and music classes, writing children's books, copying examples of folk art, producing posters, making models, and creating handcrafts. These programs of socially useful arts, while not focused on creating masterpieces, produced many excellent works, allowed thousands of artists to pursue their vocations, and enriched and informed the lives of Americans.

nication device—one way the government could reach a mass audience through art. A poster, he wrote, "provides the same service as the newspaper, the radio, and the movies, and is as powerful an organ of information, at the same time providing an enjoyable visual experience."

Government-employed graphic artists, especially those who worked for the WPA Art Project's Poster Division, experimented with new design forms, production techniques, and type styles. For example, when WPA artist Anthony Velonis first came to work for the New York City Poster Division, artists were painting posters by hand. Velonis, who had used the technique of silkscreening as a commericial artist before the Depression, made a major contribution to the graphic arts by adapting the silkscreen process to poster production. Silkscreening allowed posters to be inexpensively produced in several colors, in a variety of designs, and in large quantities. During its existence, the

> *"The artist for the first time in our history has a chance to produce with the sure knowledge that his work will be used by the society in which he lives."*
>
> —Ralph M. Pearson, **America Today, A Book of 100 Prints**, 1936

Nowhere can the New Dealers' desire to serve the wider community through art be seen more clearly than in the posters produced by federal agencies during the Great Depression. Government-created posters promoted health, safety, and tourism; advertised community events; and warned of crime, fire, and other dangers. Not surprisingly, they also were useful in advocating New Deal social programs and policies. Ralph Graham, head of the Chicago WPA poster division, saw the poster as a commu-

Poster Division printed more than 2 million posters from 35,000 designs (figs. 98, 100).

Velonis's instructional pamphlet describing the silkscreen process, **Technical Problems of the Artist: Technique of the Silk Screen Method,** for which he also designed the cover art, was widely distributed to WPA art centers around the country. In his own work, Velonis aspired to raise the level of poster design to art. His "East Side West Side," which advertised a New York WPA photography exhibit, shows what could be accomplished

99
"See America Visit the National Parks"
By Harry Herzog, Federal Art Project, WPA, undated
Silkscreen
Franklin D. Roosevelt Library, National Archives and Records Administration (Y-15)

100
"Midsummer Night Symphonies"
By an unknown artist, Southern California Federal Art Project, ca. 1937
Silkscreen
National Archives, Records of the Work Projects Administration
(69-TP-132)

through screen printing (fig. 102). Its cubist-influenced design, multiple colors, and creative use of perspective make an engaging view that captures the photographer's craft from a subject's point of view.

Two more posters, one designed by a WPA artist and one by an artist working for the Labor Department's Children's Bureau, demonstrate the information government officials hoped to communicate through this graphic medium. "See America Visit the National Parks" was designed by New York City

Poster Division artist Harry Herzog for the United States Travel Bureau, a New Deal agency that encouraged Americans to spend their vacations (and their money) at home (fig. 99). Herzog's minimalist design captures the beauty of a waterfall among mountains. His choice of colors— bold strokes of greens blues, browns, and purples—catch the essence of the parks' splendid settings. "May Day—Child Health Day, 1939" by F. Luis Mora (fig. 101) is typical of the many New Deal education, health, and safety posters. It shows

101

"May Day—Child Health Day, 1939"

By F. Luis Mora, Children's Bureau, Department of Labor

Photolithograph

National Archives, Publications of the U.S. Government (287-P-L5.14:M45 939)

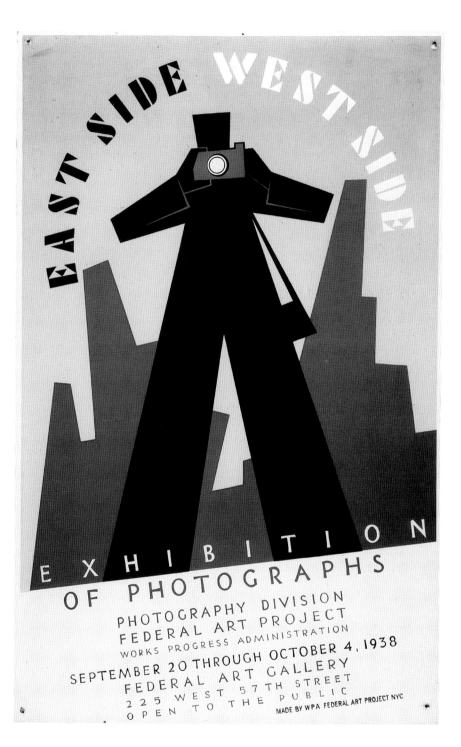

102
"East Side West Side Exhibition of Photographs"
By Anthony Velonis, New York City Federal Art Project,
WPA, 1938
Silkscreen
Prints and Photographs Division, Library of Congress
(B WPA NY V 44 2)

a group of healthy, happy children of several ethnic backgrounds walking together, seemingly into the future. The slogan on the poster— "The health of the child is the power of the nation"—highlights the national significance of child welfare and, by implication, the growing federal role in such issues.

For the most part, the Poster Division's work was less controversial than some of the other arts projects, but on at least one occasion even these lower profile projects brought unwanted publicity. In 1938 Audrey McMahon, head of the WPA's New York City Federal Art Project, suggested that its Poster Division design and print a calendar for distribution to Members of Congress and administration officials, hoping to impress them with the quality of project work (fig. 117). The strategy backfired when one Congressman took to the floor of the House brandishing a copy of the calendar as he gave a speech attacking its production as a waste of taxpayers' money.

The graphic arts also became embroiled in controversy over the New York City WPA Design Laboratory. Begun as a school for professional graphic and industrial artists, the laboratory proved a quick success. During its life as a WPA/FAP project between 1935 and 1937, it employed 25 to 35 teachers and enrolled 300 to 400 students. It gathered noteworthy artists for teachers and its board of advisers. The school even had limited success finding work for its graduates. Students found their course work heavily influenced by the German Bauhaus philosophy of Walter Gropius, who sought to mesh industrial design techniques with the fine arts. But in 1937, when the WPA announced funding cutbacks that would reduce the school's funding by one-third, one of its directors, Josiah Marvel, wrote to a number of influential individuals, urging them to support continued

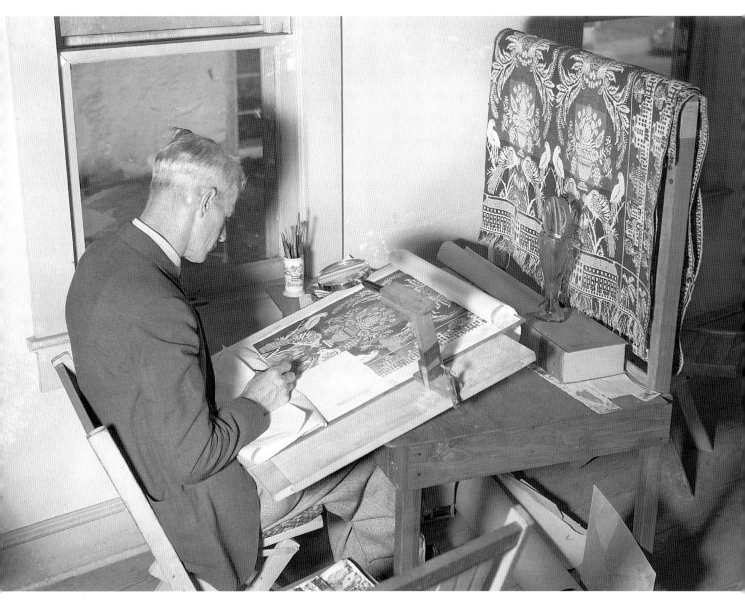

103
Magnus Fossum, a WPA artist, copying the 1770 coverlet
"Boston Town Pattern" for the Index of American Design.
Coral Gables, Florida, February 1940

National Archives, Records of the Work Projects Administration
(69-N-22577)

funding for the school. This lobbying effort only brought him a rebuke and a 1-week suspension. WPA officials, including FAP head Holger Cahill, were also critical of the Lab because it enrolled students who could afford to attend school elsewhere. At the end of 1937, the Design Laboratory lost its funding.

Another practical art project was the WPA's Index of American Design (IAD). The IAD's work was straightforward. Almost 400 artists located three-dimensional examples of American design from around the country, made renderings of these objects, and amassed a record for future study and artistic inspiration. The inspiration for assembling this visual record of American design came from two people: textile designer Ruth Reeves and New York Public Library staff member Romona Javitz. The two women approached Holger Cahill with their idea. Cahill was enthusiastic about its possibilities, but he scaled down their plan so that only examples of folk and vernacular art from Americans of European origins would be represented. The Index's drawings and paintings suggest the Depression era's need for stability and durability, but Cahill also saw the IAD as an opportunity to "recover a usable past." He hoped the IAD's renderings would inspire contemporary designers to seek out the "continuity of the aesthetic experience with the daily vocations of the American people" and that manufacturers would reproduce the designs in inexpensive mass-produced versions. As part of this effort, several exhibitions of the Index's drawings were held in urban department stores where, it was hoped, consumers and retailers might grasp the potential that traditional design had for modern-day products.

Individual IAD work included renderings of American glassware, tobacco shop figures, toys, ships' figureheads, weather vanes, religious icons, tavern signs, railroad parlor cars,

quilts, and furniture (fig. 103). Two IAD artists, Jerome Hoxie of the Connecticut project and John Davis of the Maine project, produced reproductions of ship carvings. Hoxie's painting of the figurehead for the **Lady Blessington** shows a young woman in a bright blue dress, her long brown hair flowing behind her (fig. 107). Davis's rendering is of a carving from the paddle-wheel steamer **State of Maine,** built in 1855 (fig. 106). The image, which is similar to the Maine state seal and shows two men, one a seaman and the other a farmer, standing next to a sheaf of wheat. Both figures flank a scene of the Maine countryside and coast. The carving is emblazoned with the Maine state motto: "Dirigo"—"I Direct."

In yet another IAD undertaking, the **Portfolio of Spanish Colonial Design in New Mexico,** artists from the New Mexico Index, most notably E. Boyd, crossed the state searching for examples of what the text that accompanied the published **Portfolio** called "a cross section of the characteristic type of material made in New Mexico during Colonial times." Most of the images are reproductions of religious folk art painted on wood panels, called "retablos," or renderings of three-dimensional religious icons, called "bultos." Such icons decorate Catholic churches and homes throughout the American Southwest. Two of these renderings of this religious art, **Annunciation to the Virgin** and **The Holy Family,** show the "archaic ruggedness and spiritual intensity" of the originals as well as demonstrate the faithfulness to detail and color that is typical of the best of the Index's work (figs. 104, 105).

Other WPA artists crafted three-dimensional models and dioramas for use as teaching tools by museums and government agencies. These included tactile models of historic buildings for blind persons to touch, Native American villages, architectural mod-

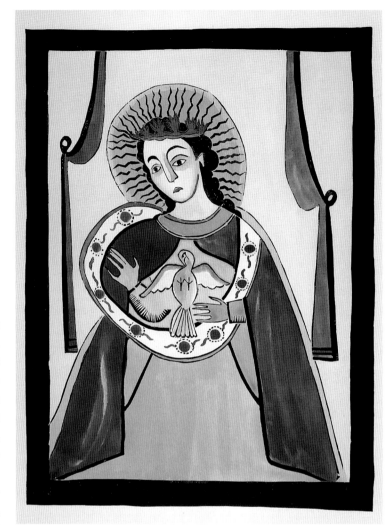

els, theatrical set designs, and dioramas showing dangerous public health conditions. John Looff, a retired sea captain, built his model of the **Discovery,** a British ship that surveyed the western coast of North America between 1791 and 1795, probably for a museum (fig. 108). Florence Kerr, a WPA administrator who knew of FDR's love of the sea, presented it to the President in 1941.

The 1930s also saw a revival of traditional handcrafts, led in large part by WPA handcraft projects. Several early New Deal relief agencies had employed women on sewing projects during 1933–34. The WPA continued but expanded the scope of these undertakings. Under Florence Kerr, who directed the WPA's Womens and Professional Division, these handcraft activities grew to embrace a variety of other skills.

In all, there were handcraft projects in 43 states. A Virginia weaving unit wove textiles into products such as coverlets, towels, bedspreads, and table linens. The quality was so high that President and Mrs. Roosevelt ordered table linens from the project for the Presidential yacht, draperies and upholstery for his office in Hyde Park, New York, and coverlets for the White House. Projects in Kansas, Oklahoma, and Montana hired Native Americans to teach silversmithing and other crafts, thus preserving these native skills for later generations. In Miami, Florida, the Negro Sewing Center made hats, mats, shoes, and belts from cabbage palmetto fronds. Other projects around the country included ceramics, doll making, quilting, furniture making, silversmithing, and basketry.

One of the most acclaimed of these handcraft undertakings, the Milwaukee Handcraft Project, began in 1935 as an experiment aimed at employing workers who were considered unemployable because of age or disability. The project soon became a thriving business; it printed a catalog of its products for national distribution and employed up to 900 workers who made rugs, draperies, furniture, wall hangings, and toys that were purchased by public institutions such as hospitals and schools. The venture became so successful that newspaper articles touted it as "the project that made Milwaukee famous." One of its wall hangings was

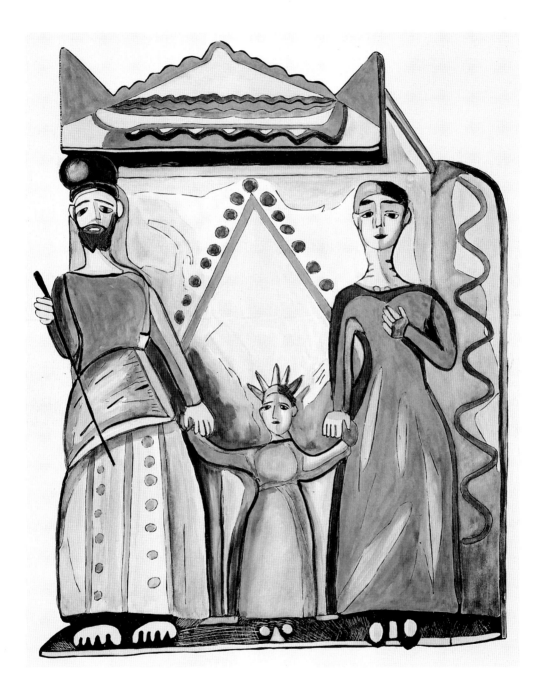

105
THE HOLY FAMILY
Printed and hand-colored by the workers of the Index of American Design,
New Mexico Federal Arts Project, WPA, 1938
Original rendering by E. Boyd, Index of American Design, New Mexico
Federal Art Project, WPA, 1936
Hand-colored woodblock
From PORTFOLIO OF SPANISH COLONIAL DESIGN IN NEW MEXICO
Franklin D. Roosevelt Library, National Archives and Records Administration
(MO 56-237 (28))

given to First Lady Eleanor Roosevelt by the project and was later found among her belongings after her death (fig. 109).

Perhaps the ultimate example of WPA practical craftsmanship is Timberline Lodge on Mount Hood, Oregon. Built in 1937–38 at the mountain's 6,000-foot mark, Timberline Lodge was intended to show the nation that those employed by the WPA were capable of much more than "make work" relief projects. WPA workers earning between 50 and 90 cents an hour built the entire lodge and its furniture, wove its draperies and bed covers, and created its decorative art (fig. 116). They wove rugs made from old CCC blankets, painted watercolors for each room, and carved the newel posts and ends of the pilasters in the shape of native animals (fig. 115). Hand-forged decorative ironwork in the lodge ranges from door handles and small

lamps to large andirons, window grilles, and chandeliers. The Oregon Art and Writers' Project later jointly chronicled the lodge's construction in **The Builders of Timberline Lodge.** The cover art for the booklet is based on the design for the lodge's wrought iron gates (fig. 114). Its design encompasses themes such as animals, the sun and moon, pinecones, and Native American symbols. Today, Timberline continues to operate as a lodge and ski resort.

Because it hoped to employ a broad variety of professionals ranging from lawyers to historians to journalists, the WPA's Writers' Project was especially oriented toward the useful arts. The FWP staff members compiled indexes to newspapers such as the **Cleveland Plain Dealer** and **Oregon Spectator.** They assisted with the research on **The Universal Jewish Encyclopedia.** In addition to The American Guide travel books, they wrote publica-

106
Carving for STATE OF MAINE
By John Davis, Index of American Design, Maine Federal Art Project, WPA, undated
Watercolor
Franklin D. Roosevelt Library, National Archives and Records Administration (MO 56-227)

107

Figurehead for LADY BLESSINGTON

By Jerome Hoxie, Index of American Design,
Connecticut Federal Art Project, WPA, undated
Watercolor
Franklin D. Roosevelt Library, National Archives
and Records Administration (42-35-1)

tions on subjects ranging from animals (**Who's Who in the Zoo**) to fishing (**An Angler's Guide to Washington, DC**) to children's literature. Two examples of the latter are **The Old Woman of the Iron Mountains,** by Norma Keating with illustrations by Clara Skinner, and **Woollies,** by Wilson Morris with illustrations by Henry Glintenkamp (fig. 113). FWP children's books, which included new works as well as classics, were developed by the New Reading Materials Project, which was jointly run by the WPA and the New York City Public Schools. Federal Writers' project authors wrote new stories, and Federal Art Project artists illustrated the books.

Public educational activities were crucial to making the art projects socially useful, and such activities were central to the FAP's mission under Cahill. WPA community art centers sprang up around the country—Arizona

alone had over 100—offering painting, printmaking, and other art education classes for adults and children (fig. 110). Most of these centers exhibited WPA traveling shows as well as displayed their own students' work (fig. 111). The FAP also sponsored national "Art Weeks" in 1940 and 1941. The WPA, with support from local women's clubs, school boards, museums, and art schools, held exhibitions and art sales throughout the country. The goal of these efforts was, according to its slogan, "American Art for Every American Home." Sales were dismal, but some 5 million people attended the sales exhibitions.

In addition to its concerts, recitals, and music festivals, the Federal Music Project reached out to communities through a variety of activities such as music classes for adults and children; music therapy programs in hospitals, prisons, and reformatories; and training classes for music teachers. In an innovative use of the radio as a teaching tool, the Music Project made a series of recordings to introduce the general public to classical music, music history, and harmony. The recordings were especially effective in making

entertainment and music education available in towns and cities too small for their own project. Music Project workers were also employed as music copyists in most large cities. Their labors made musical scores available to researchers and the general public through university and public libraries (fig. 112). A collaborative project between the New Mexico Music Project and its Writers' Project and Art Project created **The Spanish-American Song and Game Book,** an illustrated volume that reproduced the words and music to traditional Hispanic children's play activities. The San Francisco Music Project compiled a **History of Music in San Francisco.**

To reach a broad audience, the Theatre Project produced foreign language dramas, drama therapy in hospitals, and theater for the blind. As always, "Living Newspapers" were crucial to the FTP's efforts to use the theater to educate. One such "newspaper," **Spirochete,** describes the history of humanity's struggle against venereal disease. Public health experts such as the Surgeon General assisted with the script's development and endorsed its proposed solution—nationwide premarital screening. The advertisement shown here emphasizes the play's position that prudery and ignorance only aided the spread of this scourge (fig. 118).

By broadly defining art, the New Deal projects moved into areas outside of what we today might label "high art." Holger Cahill called these types of outreach activities, "beauty for use." The arts projects entered into these socially useful projects partially for practical considerations. Activities like copying music, writing children's books, weaving, making posters, and art education allowed the projects to employ more people, and they gave talented individuals a chance to maintain or pass on their skills. But such practical considerations are only part of

the reason why the arts projects entered into these socially useful projects. This kind of work was close to the hearts of those who ran the arts projects, especially the WPA projects. Through them they could expose more Americans to the arts and, they hoped, make the arts more popular and democratic.

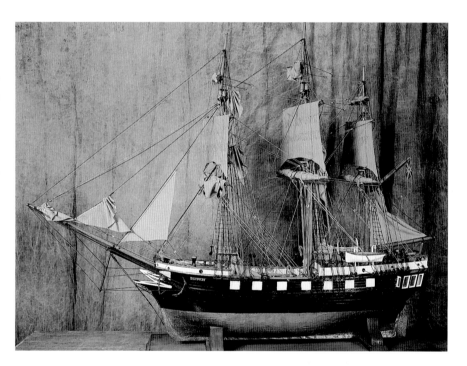

108
Scale model of the DISCOVERY
By John Looff, Washington Federal Art Project, WPA, 1937
Wood, copper, linen, and cord
Franklin D. Roosevelt Library, National Archives and
Records Administration (42-168-1)

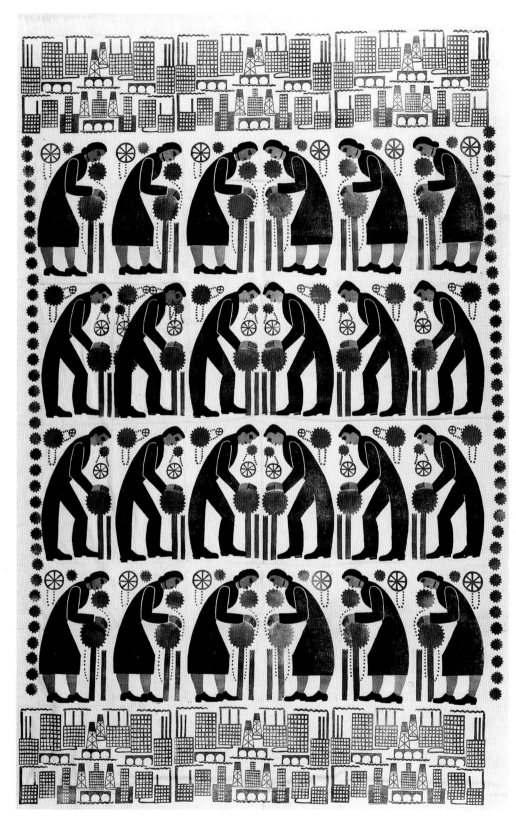

109
Wall Hanging by WPA Handcraft Project, Milwaukee, Wisconsin
By an unknown artist, Milwaukee Handcraft Project, WPA, ca. 1940
Block-printed cloth
Franklin D. Roosevelt Library, National Archives and Records Administration
(MO 70-117B)

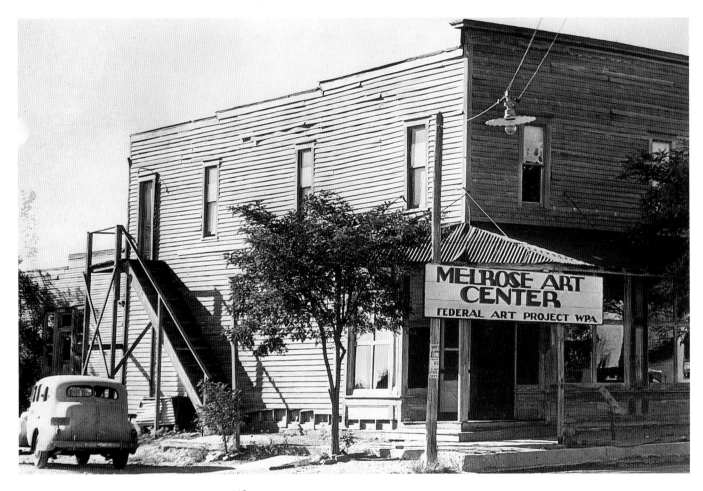

110
Federal Art Project Art Center in Melrose, New Mexico
By Virginia Stephens, undated
National Archives, Records of the Work Projects Administration
(69-N-20897)

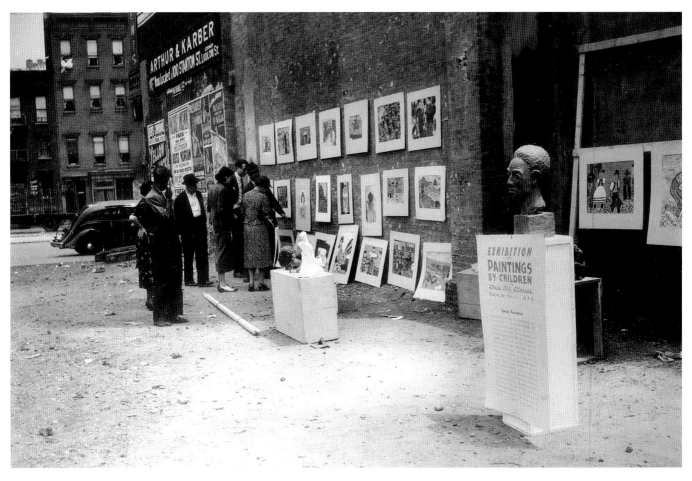

111
"Outdoor Exhibit, Ludlow and Houston Streets, New York City"
By Sol Horn, June 20, 1938
National Archives, Records of the Work Projects Administration
(69-AN-823-3091-7)

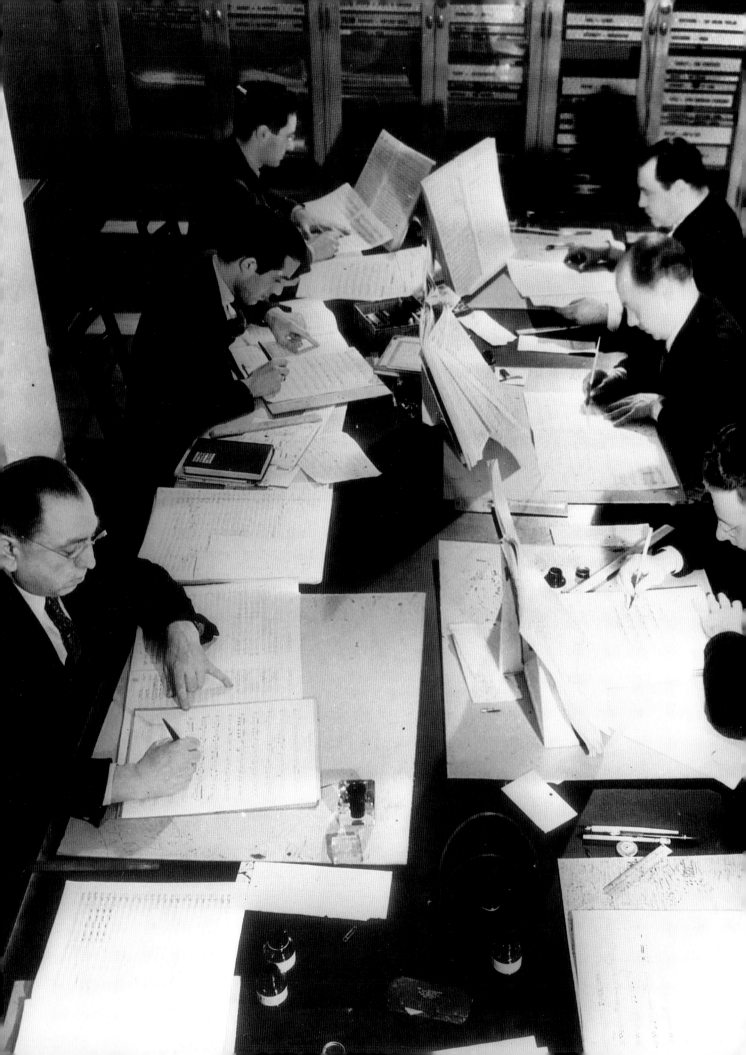

113

WOOLLIES

By Wilson Morris, New York City Federal Writers' Project, WPA, ca. 1936

Woodcuts by H. Glintenkamp, New York City Federal Art Project, WPA, ca. 1936

National Archives, Records of the Work Projects Administration

112 (Opposite)

**Copyists working for the Federal Music Project at the Free
Library in Philadelphia, Pennsylvania, January 1936**

National Archives, Records of the Work Projects Administration

(69-N-6457)

118

OCT 2 2 1937

Y3.W89²:
24 T481

THE BUILDERS OF
TIMBERLINE LODGE

114
THE BUILDERS OF TIMBERLINE LODGE
Art by the Oregon Federal Arts Project, WPA, 1937
Story by the Oregon Federal Writers' Project, WPA, 1937
National Archives, Publications of the U.S. Government

115
Hand-carved big-horned sheep, Timberline Lodge, Oregon
By an unknown photographer, undated
National Archives, Records of the Work Projects Administration
(69-N-11776)

116
View from main lounge into dining room, showing wrought-iron gates and dining room fireplaces topped by a hand-carved wood panel
By an unknown photographer, undated
National Archives, Records of the Work Projects Administration
(69-N-11790)

117
"June" (page from "Federal Art Project 1939")
By Alexander Dux, Poster Division, New York City Federal Art Project, WPA, 1938
Silkscreen on coated paper
National Archives, Records of the Work Projects Administration

118
Handbill for Chicago, Illinois, production of SPIROCHETE
Illinois Federal Theater Project, WPA, 1938
National Archives, Records of the Work Projects Administration

119
"Children's Art Class. New York City"
By Sol Horn, New York City Federal Art Project, WPA, undated
National Archives, Records of the Work Projects Administration
(69-ANP-5-2888-9)

ENDINGS AND LEGACIES

By the late 1930s, a coalition of Republicans and conservative Democrats controlled Congress while President Roosevelt was increasingly preoccupied with foreign affairs. This combination made the New Deal arts projects especially vulnerable to attacks from conservatives, who believed them to be wasteful, propagandistic, and filled with Communists. Criticism of the projects, particularly of the Federal Theatre and Writers' Projects, mounted. They were, according to accusatory accounts, "honeycombed" with radicals—"seats for the distribution of communistic literature." A New York newspaper denounced the FTP as a "seeding ground for a sort of giggly school girl radicalism." One enraged taxpayer wrote to her Senator decrying the modern "art" displayed at WPA art centers: "Look at the stuff. See if its worth it, green men with purple beards, Mexican women, nude with not a thing human about them."

Supporters of the projects replied by pointing to the projects' tangible accomplish-

tive climate gave more room for detractors to attack them.

In the autumn of 1938, a committee of the House of Representatives headed by Representative Martin Dies of Texas investigated the Theatre Project looking for communism and other "un-American activities." The Congressmen heard testimony, much of it from disgruntled former FTP employees, that the project was controlled by the Communist Party, that its plays were propaganda, and even that it promoted interracial dating. Although many of the charges remained unsubstantiated, such testimony generated a great deal of negative publicity for the FTP. WPA officials made things worse when they ordered FTP director Hallie Flanagan not to respond to the charges. Other investigations followed, and by the spring of 1939 several Congressmen were blasting the Federal Theatre Project on the floor of the Senate. Its productions were, according to Senator Everett Dirksen of Illinois, "salacious tripe." "If anybody has an interest in real cultural values you will

> "*If you want this kind of salacious tripe, very well vote for it, but if anybody has an interest in real cultural values you will not find it in this kind of junk . . .*"
>
> —Senator Everett Dirksen, speaking against further funding for the Federal Theatre Project, June 16, 1939

ments—the numbers employed, the books published, the hospital patients entertained, the arts centers opened, the concerts given. They also hastened to point out that employment on the various projects was given without regard to political affiliation. But certainly the art projects stirred up their share of controversy. Most important, a more conserva-

not find it in this kind of junk." Congress's growing hostility toward the projects and their usefulness is reflected in one Member's suggestion for employing arts project workers: "What the Hell—Let's have 'em have a pick and shovel." In June, Congress abolished the Federal Theatre Project, and by July 1 all its theaters were dark.

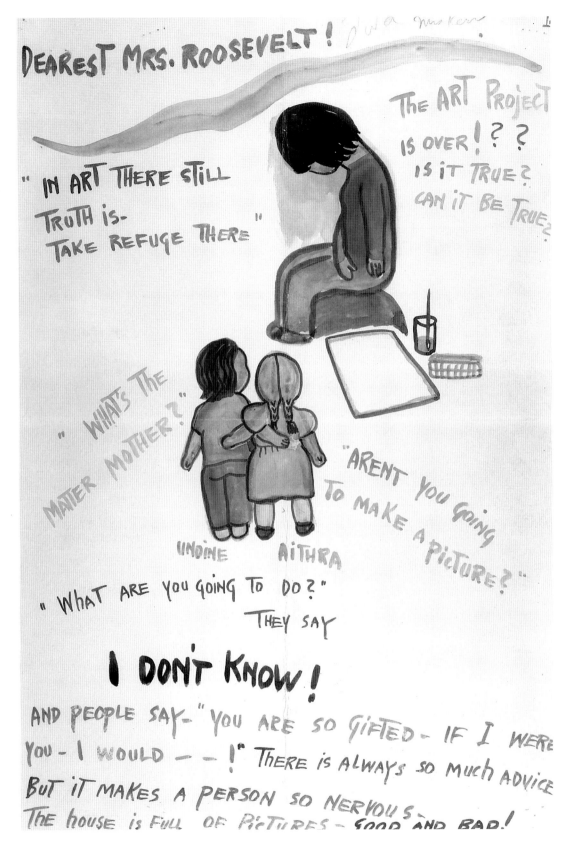

DEAREST MRS. ROOSEVELT!

THE ART PROJECT IS OVER! ? ? IS IT TRUE? CAN IT BE TRUE?

"IN ART THERE STILL TRUTH IS. TAKE REFUGE THERE"

"WHAT'S THE MATTER MOTHER?"

UNDINE AITHRA

"AREN'T YOU GOING TO MAKE A PICTURE?"

"WHAT ARE YOU GOING TO DO?" THEY SAY

I DON'T KNOW!

AND PEOPLE SAY- "YOU ARE SO GIFTED - IF I WERE YOU - I WOULD - - !" THERE IS ALWAYS SO MUCH ADVICE BUT IT MAKES A PERSON SO NERVOUS. THE HOUSE IS FULL OF PICTURES - GOOD AND BAD!

120 (Above and opposite)
Illustrated letter from Gisella Loeffler to Eleanor Roosevelt,
July 27, 1939
Watercolor
National Archives, Records of the Work Projects Administration

LOS GRIEGOS NEW MEXICO JULY 27-1939

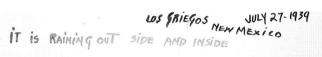

IT is RAINING OUT SIDE AND INSIDE

WE LIVE IN AN ADOBE HOUSE — WHEN THE SUN OUT OF
DOORS GLARES AND BURNS — IT IS COOL AND DUSKY INSIDE
BUT NOW THERE IS A FIERCE THUNDER STORM AND
THE ROOF IS LEAKING

IT is just THREE DAYS NOW SINCE THE BAD NEWS.
PEOPLE THAT HAVE BEEN ON THE PROJECT MORE THAN
18 MONTHS — MUST GO OFF FOR 30 DAYS! **THEN—**
I HAVE BEEN THINKING — THINKING — THINKING — ABOUT WHAT
TO DO NEXT— GO TO A BIG CITY — AND SHOW THE PICTURES
SOMEWHERE (BUT THAT TAKES MONEY) ILLUSTRATE A
BOOK — PLENTY OF FUNNY EXPERIENCES RIGHT IN THIS
LITTLE ADOBE VILLAGE — BUT THAT TAKES TIME — AND AGAIN
WHAT WILL THERE BE TO LIVE ON IN THE MEAN WHILE ? ?
WHY MUST IT END THIS WAY ? ? I HAVE JUST FINISHED
ILLUSTRATING A BOOK OF SPANISH GAMES — IN NEW MEXICO —
BEFORE THAT I DID TEMPERA PANELS FOR THE SOCORRO
SCHOOL OF MINES — BEFORE THAT THE MURALS AT THE
CARRIE TINGLEY HOSPITAL AT HOT SPRINGS — ON THE
ART PROJECT IN NEW MEXICO — IT IS A DREADFULL BLOW!
I DON'T KNOW WHAT TO DO ? SEVERAL YEARS AGO — BEFORE
THE ART PROJECTS — I DECORATED DR. VILLARY BLAIRS OPERATING
ROOM AT THE BARNES HOSPITAL IN ST. LOUIS. IT WAS THE FIRST
OPERATING ROOM EVER DECORATED — AND WAS REPRODUCED AT THE
WORLD'S FAIR IN CHICAGO. MOST OF MY WORK IS FOR CHILDREN —
I JUST LOVE TO DO THINGS TO MAKE CHILDREN HAPPY ! ABOUT 6
YEARS AGO I DECORATED THE DINNING ROOM AT THE MICHAEL'S SCHOOL
FOR CRIPPLED CHILDREN IN ST. LOUIS. THAT WAS A GOVERNMENT
PROJECT — BUT A DIFFERENT KIND — THAN THE ONE I HAVE
BEEN ON FOR THREE — YEARS — NOW !

Congress allowed the other WPA arts projects to continue, but it insisted that the states assume their supervision along with 25 percent of their cost. It also imposed stiff requirements for continued employment. An artist could be employed for only 18 months before being removed from the project's rolls. The new rule immediately threw hundreds out of work. One of them, Gisella Loeffler of New Mexico, wrote an illustrated letter to Eleanor Roosevelt describing her experiences on the projects and asking the First Lady for help (fig. 120).

For the next 3 years, as war loomed, the remaining projects struggled to prove their worth by directing their energies toward defense work. Music project bands performed at Army camps; writers wrote civil defense brochures; graphic artists produced posters urging increased industrial production, designed camp insignias, and drew charts showing the silhouettes of aircraft. One WPA artist who turned his turned his attention to promoting wartime industrial production was Ches Cobb, an artist with the Southern California Federal Art Project. His poster "Production Lines are Battle Lines," done for the War Production Board and Office of Emergency Management, is typical of these defense-related efforts (fig. 122).

Non-WPA art projects continued, but their aims shifted, too. The FSA photography projects were taken over by the Office of War Information, where its photographers concentrated on recording patriotic images of community mobilization. The Section of Fine Arts, now run by the Federal Works Administration, continued to commission murals, but they sometimes took on more military themes. Some communities objected to using taxpayers' money to paint murals in wartime. In Cortland, New York, for example, one prominent citizen claimed that "a

good many people absolutely refused to buy [war] bonds" as long as the government was using tax dollars for murals.

By 1943 all the projects were gone. Although the federal government never completely abandoned the arts, its efforts after the 1930s were much smaller. During World War II the Office of War Information and the State Department mounted exhibits in this country and abroad in support of the war effort. In the decades after the war, many of the government's entries into the arts were tied to cold war propaganda. The United

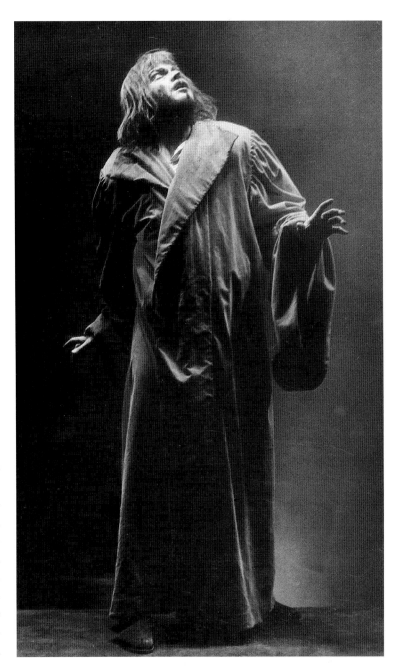

121
Orson Welles as Doctor Faustus
By an unknown photographer, 1937
National Archives, Records of the Work Projects Administration (69-TC-NYC-124-7)

122

"Production Lines are Battle Lines!"

By Ches Cobb, Southern California Federal Art Project, WPA, undated

Serigraph

National Archives, Records of the Office of Government Reports

(44-PA-1582)

States Information Agency, for example, sponsored foreign tours of American artists, ranging from jazz musicians to symphonic orchestras.

During the 1960s the federal government once again entered into arts and culture more vigorously when Congress funded three new federal programs to support them. In 1963 the General Services Administration created its Art in Architecture Program, which allocates $\frac{1}{2}$ percent of the cost of constructing and purchasing federal buildings to art. In 1965 Congress established the National Endowment for the Arts (NEA) and the National Endowment for the Humanities (NEH). In recent years government support to the NEA and NEH has become especially controversial, and their funding has been dramatically reduced. But even at the peak of their spending, these agencies, too, were dwarfed by the Depression-era programs.

Born of economic misfortune, the New Deal projects stand as unique experiments in federal patronage for the arts. While they share certain continuities and controversies with their latter-day descendants, they were much more extensive and comprehensive. For a total cost of about $83,500,000 over 11 years, the arts projects employed thousands across the country. They also involved the federal government much more directly in the arts than their successors, since Washington directly paid these artists to work at their crafts either by an hourly wage or through commissioned artworks.

Certainly, the arts projects were begun primarily as a short-term response to a temporary economic emergency, but they soon became much more. While it is easy to minimize the federal government's venture into the arts as "make work," or more charitably, a purely pragmatic response to unemployment, those who ran the projects and many who worked for them would not agree. They believed they had altered the way art was produced in American society, freeing it from reliance on wealthy patrons, democratizing it and making it available and understandable "for the millions." That the projects did not completely live up to these expectations does not make them any less innovative. Such minimizing also does not account for the artists who survived the Depression because of the projects or those individuals whose lives were changed by them. Ultimately, the achievements of the New Deal arts projects are visible not only in paintings, plays, and prose but also in talents preserved, lives enriched, and self-confidence regained.

FOR FURTHER READING

This publication is intended for a general audience. It does not contain the usual scholarly trappings of footnotes, literature surveys, or other extended bibliographic material. Nevertheless, this book and the exhibit upon which it was based were greatly dependent upon the work of many scholars who have produced shelves of books and articles about the New Deal and the arts projects. Though it is not intended to be comprehensive, the list below indicates those works that were most important to the completion of this project.

Brown, Milton. **Social Art in America, 1930–1945.** New York: ACA Galleries, 1981.

Contreras, Belisario R. **Tradition and Innovation in New Deal Art.** Lewisburg, PA: Bucknell University Press, 1983.

Daniel, Pete, Merry A. Foresta, Maren Stange, and Sally Stein. **Official Images: New Deal Photography.** Washington, DC: Smithsonian Institution Press, 1987.

Denoon, Christopher. **Posters of the WPA, 1935–1943.** Los Angeles: The Wheatley Press, 1987.

Fleischauer, Carl, and Beverly Brannan. **Documenting America, 1935–1943.** Berkeley: University of California Press, 1988.

Hills, Patricia. **Social Concern and Urban Realism: American Painting of the 1930s.** Boston: Boston University Art Gallery, 1983.

Leuchtenburg, William E. **Franklin D. Roosevelt and the New Deal, 1932–1940.** New York: Harper & Row, 1963.

Mangione, Jerry. **The Dream and the Deal: The Federal Writers' Project, 1935–1943.** Boston: Little, Brown, and Company, 1972.

Marling, Karal Ann. **Wall to Wall America: A Cultural History of Post Office Murals in the Great Depression.** Minneapolis: University of Minnesota Press, 1982.

Mathews, Jane De Hart. **The Federal Theatre, 1935–1939: Plays, Relief, and Politics.** Princeton: Princeton University Press, 1967.

McDonald, William F. **Federal Relief Administration and the Arts.** Columbus: Ohio State University Press, 1969.

McKinzie, Richard D. **The New Deal for Artists.** Princeton: Princeton University Press, 1973.

Mecklenburg, Virginia. **The Public as Patron: A History of the Treasury Department Mural Program Illustrated with Paintings from the Collection of the University of Maryland Art Gallery.** College Park, MD: University of Maryland Department of Art, 1979.

Melosh, Barbara. **Engendering Culture. Manhood and Womanhood in New Deal Public Art and Theater.** Washington, DC: Smithsonian Institution Press, 1991.

O'Connor, John, and Lorraine Brown, eds. **Free, Adult, Uncensored: The Living History of the Federal Theatre Project.** Washington, DC: New Republic Books, 1978.

O'Conner, Francis V., ed. **Art For the Millions.** Boston: New York Graphic Society, 1973.

———. **The New Deal Art Projects: An Anthology of Memoirs.** Washington, DC: Smithsonian Institution Press, 1972.

Park, Marlene, and Gerald E. Markowitz. **Democratic Vistas: Post Offices and Public Art in the New Deal.** Philadelphia: Temple University Press, 1984.

———. **New Deal for Art: The Government Art Projects of the 1930s with Examples from New York City and State.** Utica, NY: The Brodock Press, Inc, 1977.

Pells, Richard, H. **Radical Visions and American Dreams: Culture and Social Thought in the Depression Years.** New York: Harper & Row, 1973.

Penkower, Monty Noam. **The Federal Writers' Project: A Study in Government Patronage of the Arts.** Urbana, Il: University of Illinois Press, 1977.

Sporn, Paul. **Against Itself: The Federal Theater and Writers' Projects in the Midwest.** Detroit: Wayne State University Press, 1995.

INDEX

Titles of works and page numbers of illustrations are in **boldface** type.

Muralist Jacques Van Aalten at work in the New York City
WPA Mural Department
By an unknown photographer, undated
National Archives, Records of the Work Projects Administration
(69-N-18601)